IMAGES
of America

WORTHINGTON
AND SPRINGDALE

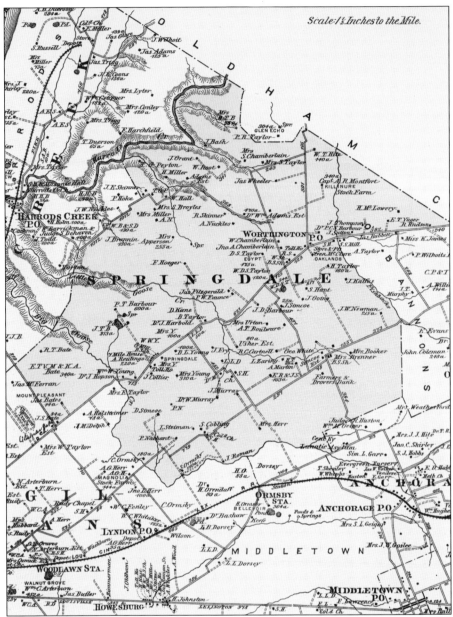

The Beers & Lanagan *Atlas of Jefferson and Oldham Counties, Kentucky* shows property owners in 1879. At this time, many of the original large tracts were still intact, while smaller farms and house tracts were beginning to emerge. The tollhouses at Worthington and Springdale are marked, as are schoolhouses (S.H.), blacksmith shops (B.S. Sh), gristmills (G Mill), steam-sawmills (SS Mill), and other businesses. (Section from *Atlas of Jefferson and Oldham Counties, Kentucky*.)

ON THE COVER: Farmers unload their potatoes at the Worthington Potato Growers Cooperative grading shed in July 1958. Fred Stutzenberger (left) is standing on the truck cab; Carl Hounz Jr. (center) is on the back of the truck; and Fred Stutzenberger Sr. (right) is standing facing the camera. The sign on the truck reads "Edw. A. Roderer and Son." (Courtesy of Dr. Fred Stutzenberger.)

IMAGES
of America

WORTHINGTON
AND SPRINGDALE

Carol Brenner Tobe

ARCADIA
PUBLISHING

Published by Arcadia Publishing
Charleston, South Carolina

Printed in the United States of America

Library of Congress Control Number: 2014938794

For all general information, please contact Arcadia Publishing:
Telephone 843-853-2070
Fax 843-853-0044
E-mail sales@arcadiapublishing.com
For customer service and orders:
Toll-Free 1-888-313-2665

Visit us on the Internet at www.arcadiapublishing.com

To the memory of my parents—C. Bayless Brenner, for his love of local and family history, and Thelma Rupp Brenner, who carefully preserved and labeled all of the family photographs and letters, clippings, and documents that have been invaluable in putting together this book. They not only cultivated their garden on Chamberlain Lane, but nurtured enduring, strong roots in family and community for their children and subsequent generations.

CONTENTS

ACKNOWLEDGMENTS

Thanks go to Cynthia E. Johnson, Louisville Metro Historic Landmarks & Preservation; David Morgan, Louisville Metro Archives and Records; Heather Stone, Filson Historical Society, for research assistance; Mary Jean Kinsman for editing; and Kenneth Tobe for technical assistance.

Thanks also go to all of the individuals and families who shared their photographs and their memories. Reconnecting with old friends has been a joy.

Special thanks go to the following friends who helped to make *Worthington and Springdale* a reality: Barbara Edwards Anderson, Alice Wright Belknap, Carla Sue Broecker, Bruce J. Campbell Jr., Kenneth R. Jaegers Sr., MD, R. Eugene Jaegers, Shirley Moser Marshall, Linda Rothenburger Siegrist, David Simcoe, Sharon Brenner Taylor, Kenneth and Mildred Chamberlain Yochim, Chris and Mary Nell Gottbrath Zeitz, in memory of Eleanora Miller Heick and Henry Karl Heick, and in memory of the Schuler family.

INTRODUCTION

The Worthington/Springdale area is in eastern Jefferson County, Kentucky, about 12 miles east of Louisville. Although Springdale is designated as a precinct in the 1879 Beers & Lanagan Atlas, the communities have no formal boundaries. This book covers the general area adjacent to Brownsboro and Westport Roads in roughly a five-mile square and includes sites across the line in Oldham County.

Not only was the soil fertile, but the local landscape was beautiful, with rolling hills, woodlands, and abundant springs. It was beside the springs and waterways that the early settlers made their homes in the late 1700s. The tributaries of Harrods Creek—South Fork of Harrods Creek, Big Goose Creek, Little Goose Creek, Wolf Pen Branch, and Fishback (or Hite) Creek—were sites of Worthington and Springdale farmsteads, blacksmith shops, and mills. One of the mills, Wolf Pen Mill, is thought to be the oldest surviving industrial structure in Jefferson County.

The Louisville and Brownsboro Turnpike Road, which today is Brownsboro Road (KY 22), runs northeast from Story Avenue in Louisville about 12 miles to the intersection of Ballardsville Road, where Brownsboro Road turns north and continues to the village of Brownsboro. Sections of the road follow old wagon trails and survey lines. Since there was no public funding for roads, private companies sold stocks and bonds or used lotteries and subscriptions to finance the roads. The Brownsboro and Jefferson County Turnpike Company employed Irish immigrant laborers to build the road, and many of these workers died in the 1873 Asiatic cholera epidemic that struck the area. Tolls and the donated labor of residents maintained the road, and it was macadamized at the turn of the century.

From the tollhouse at Worthington to the tollhouse at Springdale, it was about three miles on the Brownsboro Turnpike. Small commercial areas around the tollhouses met the needs of the communities with blacksmith shops and general stores, and at various times there were post offices and a doctor's office/drugstore. Both of the stores—Worthington Grocery and Nachand's Grocery at Springdale—were gathering places for the communities. Both establishments had bars and served beer to regular customers who enjoyed their rural "happy hour." In the early days of Worthington Grocery, the second floor, with its stage and large seating area, served as a community center for entertainment and political gatherings.

Unlike other east-end rural retreats that were on rail or streetcar lines, Worthington and Springdale could only be reached by the Brownsboro Turnpike. An article in the January 22, 1913, *Courier-Journal* promotes an interurban line to Worthington, but it was not long until the interurban lines were being replaced by new and better automobile routes and more reliable automobiles, much to the advantage of the Worthington and Springdale garages.

The Chamberlain family, who settled in 1825, built a blacksmith shop beside a spring where Chamberlain Lane makes a right-angle turn to the east. In the 1870s, the Chamberlains moved the shop to the northeast corner of Chamberlain Lane and Brownsboro Road. The old building on the corner became Worthington Garage, and next door was the blacksmith shop. This corner

continued to be the gathering place for socializing and storytelling by the men of Worthington until it was demolished in 1969.

Worthington, according to oral history, was named for a prominent local resident, Guy Worthington Dorsey. The Worthington and Dorsey families were linked as far back as the 17th century in Maryland, and the Dorsey family emigrated from Maryland in the 1790s. Local historian and storyteller Russell Chamberlain recounts the story of the community's naming. He writes that when the local post office was established in the 1870s, it needed a name. The gathered patriarchs suggested naming it after William Chamberlain. He demurred and suggested the name Worthington, after Guy Worthington Dorsey, who was said to have been something of a playboy and adventurer. Unfortunately, research reveals no one with the name Guy Worthington Dorsey. There was, however, a local landowner named Charles Samuel Worthington Dorsey, a possible source of the name.

The naming of the community of Springdale was more straightforward. In 1830, the family of Laurence Young purchased a 1,000-acre tract of land that featured an excellent spring. They built a house over the spring and named the farm Springdale. Young kept the first records of Kentucky weather. He was a noted horticulturist and conservationist in addition to being a successful farmer. The estate remained in the Young family for many years, and his son, William Woosley Young, and his family were very active in the community. Today, the former Young property is the site of the Standard Country Club and a large private estate that retains its original rural character. Springdale was said to have been previously named Iylersburg and, for a short period, had a post office

Taylortown was an African American community on Ballardsville Road at the corner of Murphy Lane. It is said that after the Civil War, the Taylor family gave the land to their former slave Abner Taylor. This community disappeared from this location, but became clustered around the Taylortown AME Zion Church, which was established in 1868 and is still active. Many descendants of the original families are current members of the church.

The heart of Worthington was the corner where the Brownsboro Road turns north and continues to the village of Brownsboro. Ballardsville Road, which was built later, continued the easterly direction of Brownsboro Road, forming an intersection. The Tarleton family owned and operated a store in a small, log building, and there was a post office on the site in the 1870s. In 1888, the Sims family built a two-story brick building. Its second-floor hall was used for entertainment and political gatherings. The tollhouse was across the road from the store, and the storekeeper collected the tolls. Bert and Evelyn Gottbrath bought the Worthington Grocery in 1938 and operated it until 1961.

Like the Worthington Grocery, the grocery at Springdale was opposite the tollhouse and combined the grocery with a bar. Around 1870, Adam Rueling, a German immigrant wagonmaker, constructed a blacksmith shop and a grocery/saloon known as Seven Mile House. Reuling's descendants, the Nachand family, ran Nachand's Grocery until it was demolished in the early 1960s. Freibert's Garage was next door to Nachand's Grocery. It began as a blacksmith shop and, as the farmers began to replace their mule teams and wagons with tractors and trucks, adapted its services to the modern farm equipment and automobiles.

There was also a small commercial area at Fry's Hill on Westport Road. Before 1860, there was a blacksmith shop and later the Farmers and Drovers Bank and a general store. The general store was run by Gus Heinz, a German immigrant and brother-in-law to Christian Brenner, who owned the property and house at Fry's Hill. When Heinz died in 1899, Brenner's daughter Betty and her husband, Enoch "Tom" Webb, took over the store.

There were several one-room schoolhouses in the area—on Chamberlain Lane, on Goose Creek Road, and on Cherry Valley, off Wolf Pen Branch Road. School was held in the Wesley Chapel Church after services were discontinued in 1892, and Taylor Chapel doubled as a school for African American children until 1915. The Rock Bridge School, located on Ballardsville Road, was probably built in the 1850s to replace these smaller schools. An 1895 school photograph shows 40 students and one teacher. Worthington School was built in 1915, and on the opening day,

the students marched in procession along the mile from Rock Bridge to Worthington School. It closed in 1959, and the building was demolished for the highway interchange. Rock Bridge School became Worthington Colored School and was the last one-room, one-teacher school in Jefferson County when it closed in 1958 with the integration of the county schools.

The area's original landholders either received or purchased Virginia land grants that had been awarded to veterans for military service. Many of these late-1700s land grants were 1,000 acres or more, but by the mid-19th century, most had been divided into smaller farms of fewer than 100 acres. They were purchased by first- and second-generation immigrants; many were German, referred to as "Dutchmen" by the old-timers. The German families—Stutzenberger, Zeitz, Steinmetz, Brenner, Haunz, Baish, Rothenburger, and Rupp—along with a few Swiss families—Schuler, Von Allmen, and Moser—became neighbors to the earlier Sims, Littrell, Chamberlain, Young, Maddox, Garwood, Taylor, Mitchell, Goins, and Dorsey families.

No one knows which Worthington farmer planted the first crop of potatoes, but news of its success must have spread quickly. The fertile soil was especially suited for growing potatoes, which soon became the area's major crop, reaching a peak by the mid-1920s. The original structure of the Worthington Potato Growers Cooperative was built in 1916 as the Worthington branch of the St. Matthews Produce Exchange. The potato shed was a local landmark until it was demolished in 1965. In addition to potato farms, there were several dairy farms, and many farmers raised beef cattle, a popular 4-H project for their children.

In the 1950s, George W. Norton of television station WAVE purchased a farm in Worthington as a location for *Farm*, a live Saturday-morning telecast. Farm manager Paxton Marshall updated television viewers on agricultural news and seasonal farm activities. His wife, Shirley Moser Marshall, was a Louisville television pioneer with her cooking show, *Flavor to Taste*, which aired weekdays on WAVE. Today, the WAVE farm has become Norton Commons, a planned "Traditional Neighborhood" community.

Because it was close to Louisville, the Worthington/Springdale community became the location for country estates for wealthy businessmen. The landscape that attracted the early settlers also appealed to these later estate builders. A 1941 clipping from the *Courier-Journal* is titled "Best Land, Worst Farmers Found at Worthington." The reporter's premise is that the county's most fertile ground is owned by people with no farming experience. The gentlemen farmers, however, were good stewards of the land, renting their farm fields to local farmer and hiring skilled farm managers.

The earliest local church, Wesley Chapel, dates to 1824 and was located just over the line in Oldham County. Services were discontinued in 1892 and the stone building is privately owned. The Taylortown AME Church was organized by the local African American community in 1868 and originally called Taylor Chapel. In 1920, the old chapel was replaced, and the congregation built the current church building in 1958. The Worthington Church of Christ was organized in 1880 and the church building erected on Brownsboro Road in 1886. The church's second building was demolished for the expansion of Brownsboro Road in 1969. Springdale Presbyterian Church was organized in 1879 and the building constructed in 1882. The original church building remains, surrounded by modern structures. Roman Catholic families in the neighborhood attended church in Pewee Valley or St. Matthews. Today, the mega-church Northside Christian Church dominates the landscape across the road from the location of the old Worthington Church of Christ.

The Worthington Cemetery was established around 1873. Prior to the establishment of the community cemetery, burials were in family cemeteries; a number of these still exist in the area, many in the middle of subdivisions.

The same springs and streams that nurtured the early mills and shops became recreational attractions in later years. At the Rock Springs Hotel, built in 1870, the main draw was a wonderful spring purported to have healing powers. Just over the Oldham County line, the hotel burned shortly after it was built. The Sleepy Hollow Club was established in the 1920s as an exclusive hunting and fishing club. Because it was a private club, few people in the community could afford

memberships. The original spring that gave Springdale its name was made into a lake on the golf course of the Standard Country Club.

The opening of the Plantation Swim Club on Westport Road in 1957 made club membership affordable for middle-class community members and offered the first swimming pool in the neighborhood. The adjacent Plantation subdivision was, along with Pinehurst and Barbourmeade, among the first of the residential developments that would soon replace the farms and estates.

Organized by local residents in 1943, the Worthington Fire Department continues to serve the community. The volunteers built a small cement-block firehouse for $954.55 on Brownsboro Road and purchased their first fire truck for $425. During its first year, the volunteers made eight fire runs in its service area—a three-mile radius from the firehouse. The first fire chief was Carl Chamberlain, proprietor of the Worthington Garage. In 1992, the Worthington Fire Department hired its first full-time, paid crew.

In the 1960s, Worthington and Springdale began to be suburbanized with the building of Interstate 71, which bisected the community, with overpasses spanning the little country roads. The Gene Snyder Freeway exit ramp to Brownsboro Road destroyed the old Worthington School and transformed the Von Allmen Dairy Farm into an upscale shopping center. In 1969, the massive Kentucky Ford Truck Plant was built on Westport Road and changed that road into an industrial/commercial thoroughfare. There is precious little undeveloped open space in modern Worthington and Springdale. They have become upscale suburbs with amenities and conveniences that make a very popular residential and shopping area for both young families and downsizing seniors.

The people who made the early Worthington and Springdale authentic were the small farm owners, tradespeople, and professionals. They built the schools and churches, established a cemetery and volunteer fire department, and organized picnics and fundraisers. In the early 1900s, the CSW (Community Service Workers) helped those in need with their 10¢ monthly meeting dues and provided a social network for the country women. The Extension Homemakers Club was active into the 1950s and included some of the new "city" women who had moved to the country.

Although the people who grew up in Worthington and Springdale may be saddened by the loss of the unique sense of place that marked the community, they have benefitted not only from the sale of the family homes and farms, but also from the legacy of the enduring values of education, hard work, pride of place, and stewardship of the land. There have been many changes along the way, but Brownsboro Road, with its scenic hills and curves, continues along its original route, reminding commuters that it once was the only way from the city to the countryside of Springdale and Worthington.

One

WATERWAYS
AND HIGHWAYS

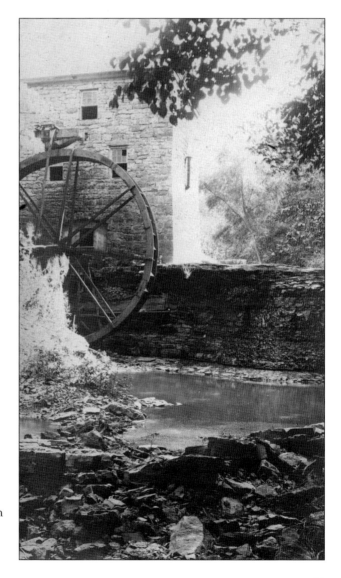

Believed to be the oldest surviving industrial structure in Jefferson County, Wolf Pen Branch Mill is built into a 10-foot waterfall on the Wolf Pen Branch of Harrods Creek. The mill was constructed in the late 1860s or 1870s by Herman "Butterbean" Miller, who, according to local legend, raised and sold butter beans to finance this building. Eva Lee Smith Robin Cooper purchased the mill and restored it to working order in 1925. This photograph was taken by Carlos Brenner, son of the noted landscape painter Carl Brenner. (Courtesy of the Filson Historical Society.)

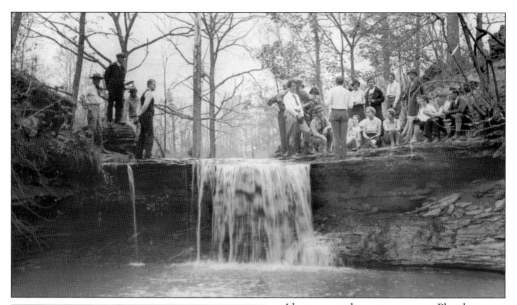

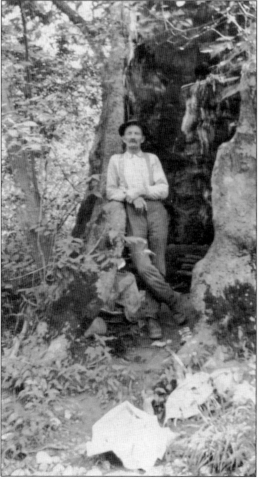

Above, a geology group tours Phoebe Falls, one of the falls on the South Fork of Harrods Creek. Col. Lucien Beckner (1872–1963), a naturalist and geologist who was curator of the Louisville Free Public Library Museum, led the expedition. Theodore Chamberlain, left, was an amateur naturalist and Indian relic collector. His favorite natural areas were the woodlands around Sleepy Hollow. He is shown here at Twin Falls on a tributary of Harrods Creek in the early 1930s. (Both, courtesy of Clara Chamberlain Cruikshank.)

Black Bridge spanned the South Fork of Harrods Creek and was said to have been built by slaves. It was in the Sleepy Hollow area and was a favorite recreation spot for locals. Shown below are the falls above Harrods Creek on the original Baisch/Garwood property. This was the location of an early mill. Below the falls was a popular swimming hole frequented by young people in the 1930s. (Above, courtesy of Clara Chamberlain Cruikshank; below, courtesy of the Garwood family.)

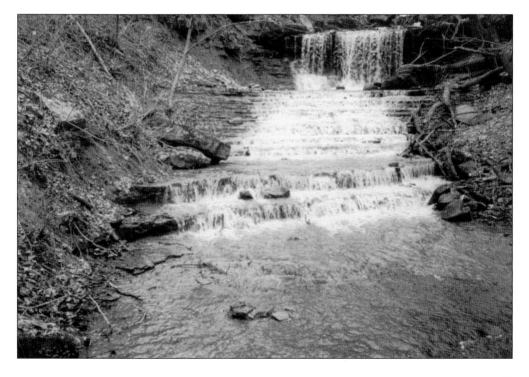

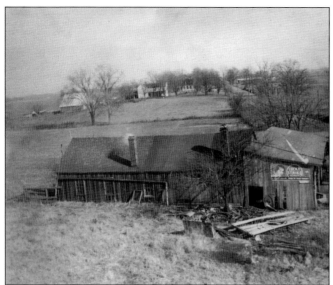

This aerial view looking east on Brownsboro Road shows the Worthington Blacksmith Shop in the foreground. The Steven and Emily Maddox house and barn are in the background. Beyond the Maddox house is the Worthington Church of Christ; across the road, the long building with the white roof is the Worthington Potato Growers Co-op. The photograph probably dates to around 1930. (Courtesy of Ann H. Chamberlain.)

Brownsboro Road has two sections of scenic curves: one where the road dips to cross Little Goose Creek, and the other just past Springdale, where it crosses the valley of Big Goose Creek. There was said to have been an African American settlement called Black Hills in the area where the road crosses Little Goose Creek. This photograph shows finished roadwork completed by the WPA in the late 1930s. (Courtesy of the University of Kentucky, Goodman-Paxton Photographic Collection.)

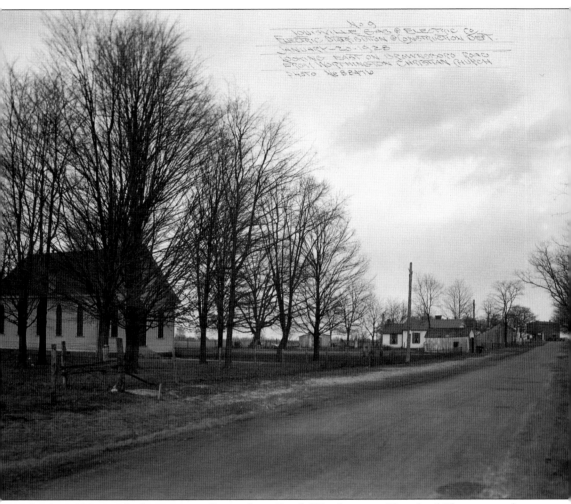

In this 1928 view looking east on Brownsboro Road, Worthington Church of Christ is on the left. Further down the road, the white house was at one time the home of Ann and Stanley Chamberlain, and the next structure would be the future site of the Worthington firehouse. The next white house was the old tollhouse, and visible in the distance is the Worthington Grocery building. (Courtesy of Archives and Special Collections, University of Louisville, Caufield & Shook Collection.)

The tollhouse at Worthington was about three miles from the tollhouse at Springdale on the Brownsboro Turnpike. This was the original tollhouse at Worthington, which sat across from the 1888 grocery building. H.H. Sims, who built the grocery, was also toll collector from 1880 to 1895. The Gottbrath family lived here when they ran the grocery. (Courtesy of Gene Gottbrath.)

This building is identified by some sources as the first Springdale tollhouse, which was moved from its original location nearby. Other sources dispute that it is the earliest tollhouse. It is definitely close to the original location, being across the road from the commercial corner. The building is on private property. (Courtesy of 7400 Old Brownsboro Road, LLC.)

Two

MAKING HOMES BY SPRINGS AND STREAMS

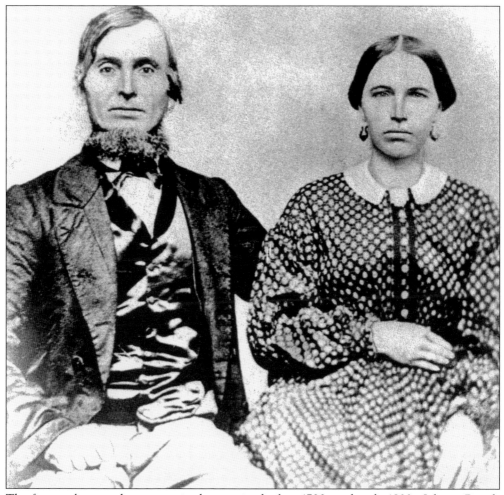

The first settlers put down roots in the area in the late 1700s and early 1800s. Johann Baisch (1818–1878) and his wife, Mary Vogeler Baish (1831–1873), emigrated from Germany to the United States in 1852 and settled in the Harrods Creek area. Johann was a stonemason and erected chimneys and stone foundations for local structures. (Courtesy of the Garwood family.)

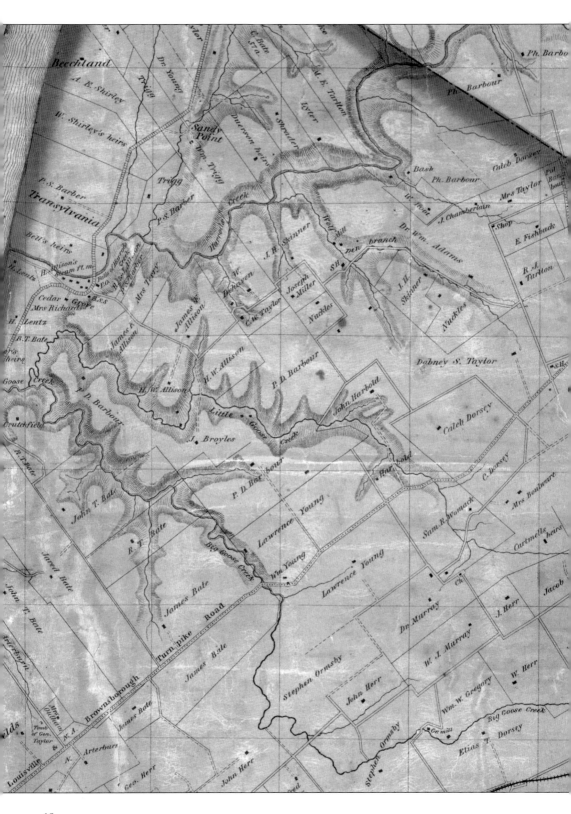

18

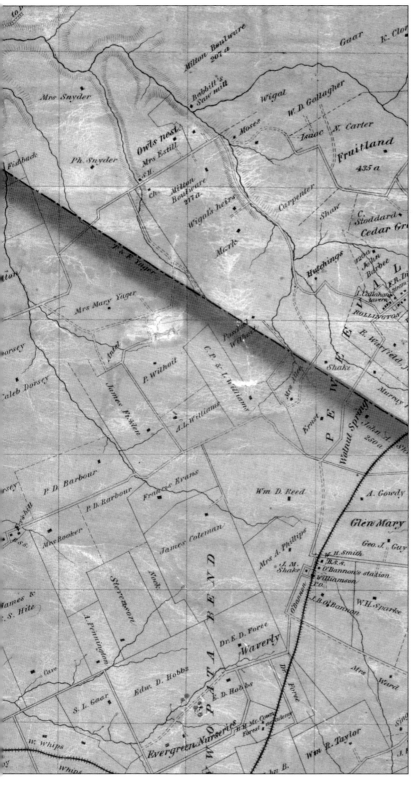

This is a section of one of the earliest maps showing the county in detail. It is the 1858 G.T. Bergmann *Map of Jefferson County, Kentucky*. A bit of the Ohio River is visible in the upper left corner, and Harrods Creek is a prominent feature, snaking from southwest to northeast. It is a good illustration of the importance of the streams to early settlement. The branches of Harrods Creek—Big Goose Creek, Little Goose Creek, Wolf Pen Branch, Fishback Creek, and the South Fork—are plainly marked. The Brownsboro Turnpike Road is prominent, running from southwest to northeast. Although the acreage of the tracts is not noted, the property lines are marked and show the large holdings of the Dorseys, Taylors, Barbours, Youngs, and others. Fry's Hill is marked as having a blacksmith shop, but there were as yet no commercial areas at Worthington or Springdale. (Section from *Map of Jefferson County, Kentucky*.)

19

In 1855, the Johann Baisch family rented, then purchased the property near the falls of the Shop Spring Branch of Harrods Creek. This was the Baisch/Garwood family home for four generations. (Courtesy of Louisville Metro Historic Landmarks & Preservation.)

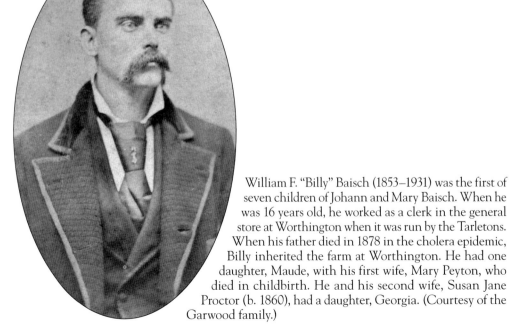

William F. "Billy" Baisch (1853–1931) was the first of seven children of Johann and Mary Baisch. When he was 16 years old, he worked as a clerk in the general store at Worthington when it was run by the Tarletons. When his father died in 1878 in the cholera epidemic, Billy inherited the farm at Worthington. He had one daughter, Maude, with his first wife, Mary Peyton, who died in childbirth. He and his second wife, Susan Jane Proctor (b. 1860), had a daughter, Georgia. (Courtesy of the Garwood family.)

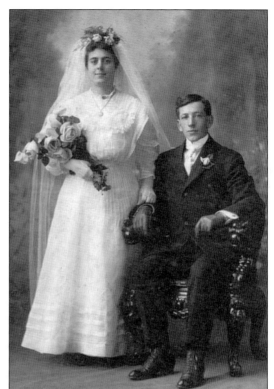

Billy Baisch's daughter, Georgia, married Edward Samuel "Ted" Garwood in 1906. They lived with the Baisch family in the family home. Ted outlived Georgia by many years and resided with his son Bill's family until he died in 1972 at age 93. In the neighborhood, he was "Mr. Ted"; within his family, he was lovingly called "Old Timer." (Both, courtesy of the Garwood family.)

On a hill above the Shop Spring, the Reuben Taylor house commanded a view of the countryside. This view will soon be lost, as development is imminent and can be seen in the background of the photograph. One of the oldest houses in the area, the home seen below is built of poplar and chestnut logs and remains in good condition. It is on Chamberlain Lane, just past where the road turns from north to east. (Both, photograph by the author.)

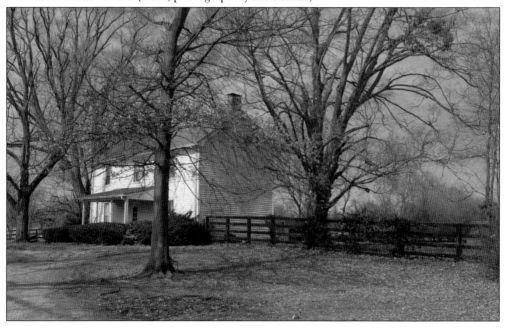

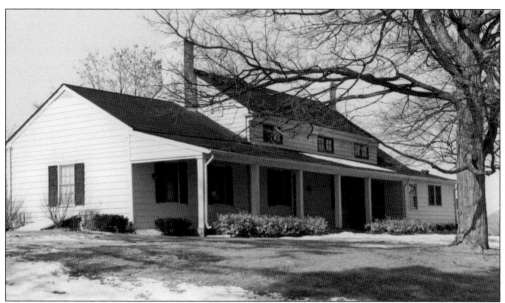

Dr. William Murray bought this tract on Little Goose Creek in 1793. According to local legend, five Murray brothers were with the Grant party that landed its flatboats on Harrods Creek in 1779. The brothers began building a large, two-story log house in 1793, but they were attacked by Indians and one brother was killed. The remaining brothers are said to have gone home to Virginia and remained there until after 1814, when they returned and completed the house they started and built others nearby. Members of the family owned the property until 1964. Built on the 1793 William Murray tract, the home seen below belonged to Jesse Murray from 1823 to 1846. He is credited with building the original brick section of the house. It was purchased by the Ewing family in the 1880s. (Both, courtesy of Louisville Metro Historic Landmarks & Preservation.)

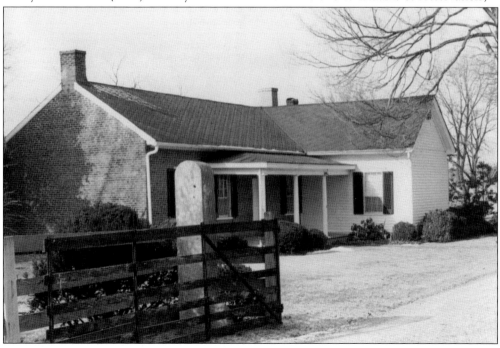

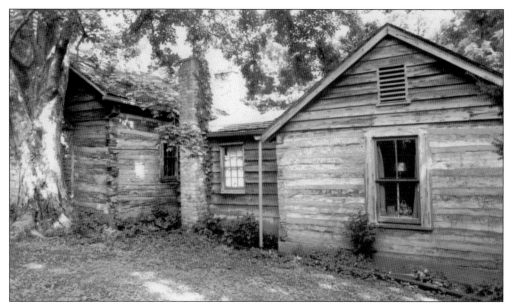

Dr. W.L. Harbold (1819–1894) settled on a 1790 military grant of 99 acres. The front log cabin (right) is the original Harbold residence, which the family occupied until about 1854, when they built a one-and-a-half–story clapboard home. The 1854 house is within the house built by Lewis Kaye in the 1940s. The rear cabin (left) was moved from another location on the property and was said to have been the first log schoolhouse in Jefferson County. (Courtesy of Louisville Metro Historic Landmarks & Preservation.)

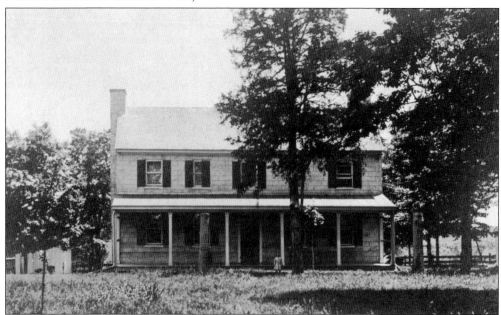

The old Simcoe home was said to have been built by William Fry around 1800. Jeremain M. Simcoe came to Kentucky from Virginia in 1810. His son John Simcoe was born in 1841 and married Annie White in 1877, and the couple moved to this farm soon after. They had one child, Hewitt. The house was located on the east side of Simcoe Lane. Henry Fischer of Fischer Packing Company purchased the farm in 1935. (Courtesy of Doris Simcoe Claiborne.)

Known as the Hite House, this was the original home of W.T. Hite, who had a 140-acre farm here in 1858, possibly earlier. The Hites were some of the first settlers and had huge land holdings in various parts of the county. Wilbur and Edith Zeitz Littrell and their son Bob farmed here from the 1930s until 1974, when a tornado destroyed the house. Wilbur and Edith sheltered in the basement and were trapped there until Wilbur's brother, Douglas, and his wife, Ivy, cleared the debris and pulled them to safety. Coincidentally, the house had sustained severe damage from a tornado in 1880. (Courtesy of Chris Zeitz.)

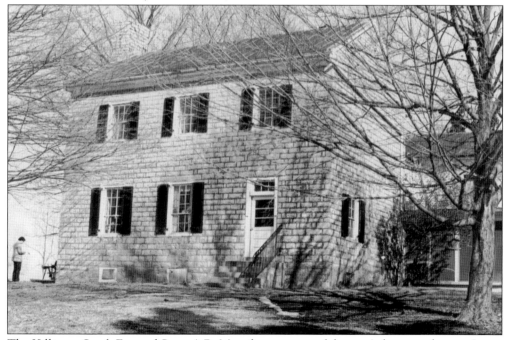

The Killinure Stock Farm of Capt. A.R. Montfort was one of the area's few stone houses. It was built on part of a 1,000-acre military survey patented to James Taylor Sr., who gave 800 acres to his son, James Taylor Jr., in 1797. The home may have been built by Taylor Jr. or by subsequent owners prior to 1827. Montfort, an Irish immigrant, purchased the farm in 1827 and gave it a Gaelic name. (Courtesy of Louisville Metro Historic Landmarks & Preservation.)

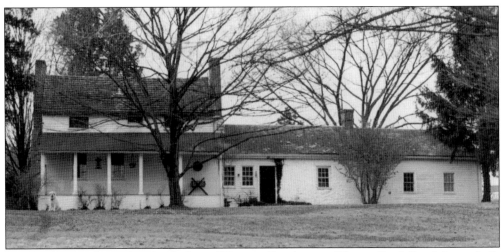

This log house is located at the dogleg in Westport Road west of Goose Creek Road. It was built by either Daniel McClure or James Boston around 1800. Peter Nachand and Lorenz Steinmetz purchased the property in 1864, and the Nachand family lived there until they moved to Springdale to take over Seven Mile House from Mary Nachand's father, Adam Rueling. Nachand's daughter and son-in-law, Annie and John Lenz, acquired the property and lived there for 20 years. (Courtesy of Louisville Metro Historic Landmarks & Preservation.)

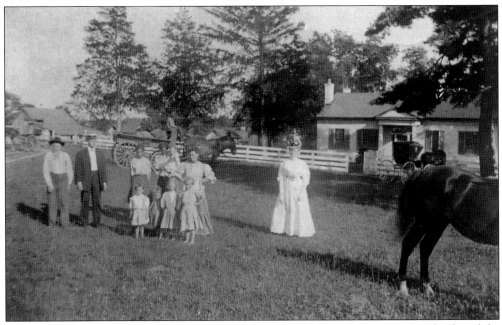

The Steinmetz home was built on property purchased in 1864 with Peter Nachand. The adults gathered in front of the family home around 1908 include, from left to right, Lorenz Steinmetz; Dr. Kiefer; unidentified hired girl; unidentified hired woman holding Frank Steinmetz; Margaret Rose Hettinger Steinmetz, wife of John Steinmetz; and Mrs. Kiefer, wife of Dr. Kiefer, in a white dress and hat. In front are the children of Margaret Rose and John—from left to right, Margaret, Laurence, Catherine, and Josephine. In the background are a hired man on the farm wagon and the doctor's buggy. The family of John and Margaret Rose moved to a farm on Hoke Lane (Springdale Road) that remained in the family until recently. (Courtesy of Lynn McGuire Selden.)

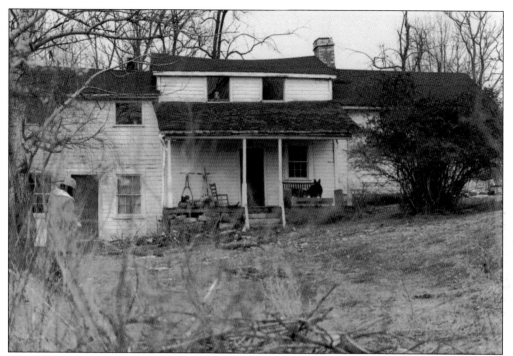

The J.W. Nuckols (1841–1923) House above was on the north side of Wolf Pen Branch Road. It was a log house, built in several stages. Below, the original log cabin at this location was probably built by T.G. Peyton around 1850 and may have been a tenant or slave cabin. A second cabin was brought from another location and combined with the original. It is east of Wolf Pen Branch Road at the right-angle turn of the road. This picture shows the house under construction. (Above, courtesy of Louisville Metro Historic Landmarks & Preservation; below, courtesy of Gene and Kenny Jaegers.)

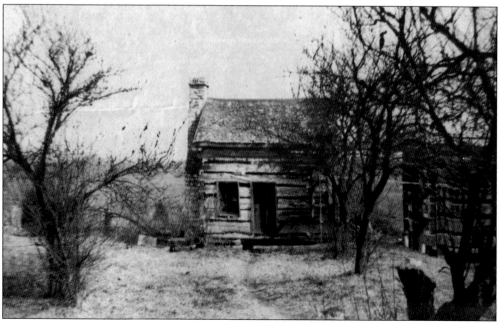

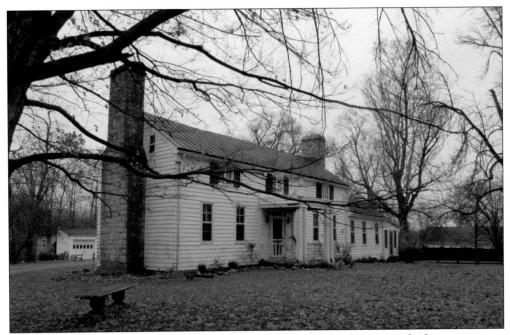

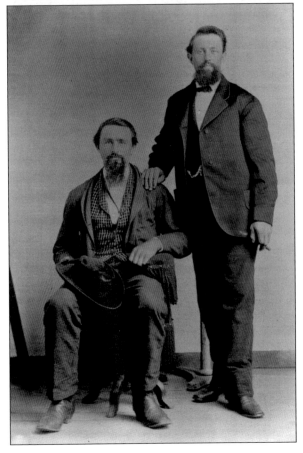

Located just over the line in Oldham County, this large, dogtrot log house originally belonged to June Mayo, and the road in front of the house was called Mayo Lane. The road, which is now cut off, crossed Harrods Creek and continued to the river. This was later the farm of Xavier Schuler, who was a livestock trader and farmer in the late 1800s. (Courtesy of the author.)

Shown here are Xavier Schuler (seated) with his brother, Karl. Xavier was born in Switzerland in 1844 and emigrated to America around 1860. He purchased the 425-acre property on Mayo (now Schuler) Lane in 1882. In addition to the Mayo Lane tract, Schuler owned a 110-acre tract at Springdale. Xavier's son, Francis Xavier, married Florence Freeman. Xavier Sr. moved to the city, and Francis Xavier and Florence lived in the log house and raised their family. (Courtesy of Gene Gottbrath.)

Edwin Schuler, son of Francis Xavier, married Magdalene Haunz and they had two daughters, Edwina and Evelyn, who grew up in the farmhouse below. This house was on the original Schuler farm. Schuler's grandson Gene Gottbrath has added to and renovated the Schuler house, making him the fifth generation to live on this farm. (Both, courtesy of Gene Gottbrath.)

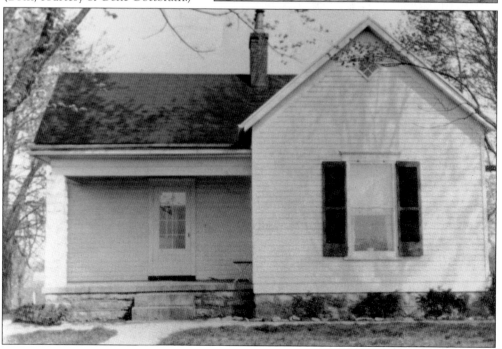

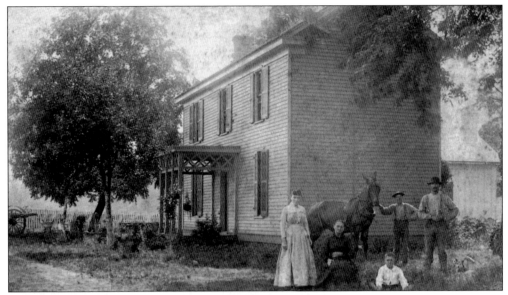

James Washington Goins (1829–1892) and Zerelda Shake Goins (1829–1910) purchased their home, seen above, from L.L. Dorsey in 1869. The rear log section is said to have been built by Caleb Dorsey around 1810. Goins had also purchased the adjacent 67-acre Thomas Hite farm. Pictured, from left to right, are Minnie Ann Goins, Zerelda Shake Goins, unidentified seated child, unidentified boy, and John Pendleton Goins. Pictured at left, James Washington Goins left the farm to his son, John Goins (1861–1937). John left the farm to his adopted daughter, Estelle Goins Head, and her son, Bobby Goins Head. The Heads added to the Goins tract and Estelle's husband, Johnny, was one of the community's most dedicated farmers. (Both, courtesy of the Brenner family.)

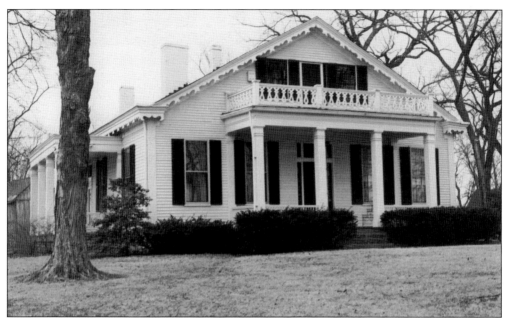

Hendery Allison purchased the land for this house around 1830 and it was built around 1844. In 1878, William Barrickman bought the site. Barrickman's daughter, Mary, married John Ewing, and the home remained in the family for many years. Below, the youth group from Springdale Presbyterian Church honored one the church's oldest members, Mary Barrickman Ewing (1875–1961). Ewing lived all her life in the house where she was born. Pictured are, from left to right, (first row) Stephen Teaford, Eugene Jaegers, Carla Sue Allgeier holding Joan Curd, Mary Lee Hatfield, and Barbara Edwards; (second row) Carol Heick, Phillip Curd, Mrs. Ewing, and Alice Curd; (third row) Carol Brenner, unidentified, unidentified, Ronnie Fisher, David Hardin, and Michael Hardin. (Above, courtesy of Louisville Metro Historic Landmarks & Preservation; below, courtesy of the Brenner family.)

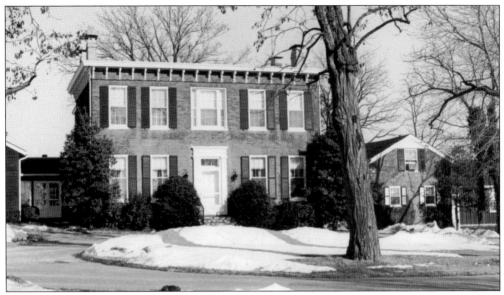

This is the Abraham L. Williams home on Murphy Lane. It was built about 1855 by Huldah Jean and Abraham L. Williams. The brick Italianate house remained in the family until 1919, and members of the family are buried in the walled cemetery close to Murphy Lane. Subsequent owners were the Terry and Schumann families, Jane Morton Norton, and the Louisville & Nashville Railroad Company, which used it as a conference center. (Courtesy of Louisville Metro Historic Landmarks & Preservation.)

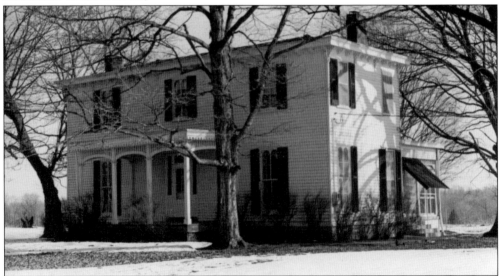

Dr. P.C.S. Barbour built this house in 1869, and it remained in the Barbour family until around 1890, when Harry Sims purchased the farm. The Sims family members were active in the Worthington community and built the brick Worthington store building where Sims served as storekeeper, postmaster, and toll collector. The house is similar in its Italianate design to the house of J.D. Barbour (Netherton) on the south side of Brownsboro Road at Simcoe Lane, and the larger, brick P.T. Barbour house on Barbour Lane. All three Barbour houses have been demolished; the Barbour Lane house was destroyed in the 1974 tornado. (Courtesy of Louisville Metro Historic Landmarks & Preservation.)

In the early 1800s, Laurence Young (1793–1872) came with his family to Kentucky from Caroline County, Virginia, and purchased about 1,000 acres in Jefferson County on Big Goose Creek. He built a house and took great pride in cultivating his land. Laurence was well educated, having studied law at Transylvania, but directed his energy to teaching and horticulture. The Youngs had a greenhouse, and Laurence was a nationally recognized pomologist who edited the *Southern Agriculturist*. Eliza White Young (1803–1891) married Laurence Young in 1823. She and Laurence lived at Springdale and had nine children, only four of whom lived to maturity. (Both, courtesy of Julia C. Young and Janet Ochsher.)

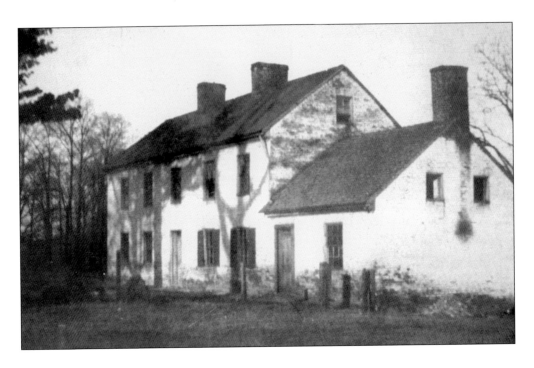

Above is the original Young family homestead built about 1828. There was an excellent spring on the property, and Laurence Young built his house over the spring and named his estate Springdale, thus giving a name to the community that grew up around the Young farm. Accounts describe a stone basement, with a spring flowing into a channel, where dairy products were cooled. The spring maintained a constant temperature of 54 degrees and was famous locally for its excellent water. On the 1858 Bergman map (pages 18 and 19), the Laurence Young holdings are located on either side of Brownsboro Turnpike. Below, the home of Laurence's son William Worsley "W.W." Young and Ann Amelia Chamberlain Young was a landmark in the community. It was on a section of the original Young property. (Both, courtesy of Julia C. Young and Janet C. Ochsner.)

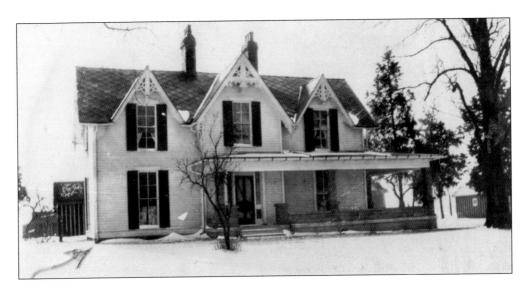

William Worsley Young (1828–1903) was the son of Lawrence and Eliza Young. He married Ann Amelia Chamberlain (1834–1909) and both were well-known citizens of Springdale. He was a prominent farmer and became the first magistrate in the Springdale precinct when it was organized in 1858; she was one of the women who organized Springdale Presbyterian Church. (Both, courtesy of Julia C. Young and Janet C. Ochsner.)

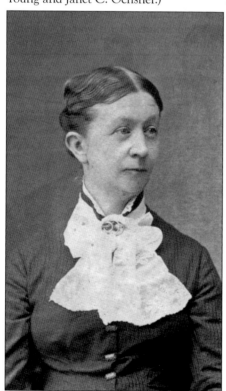

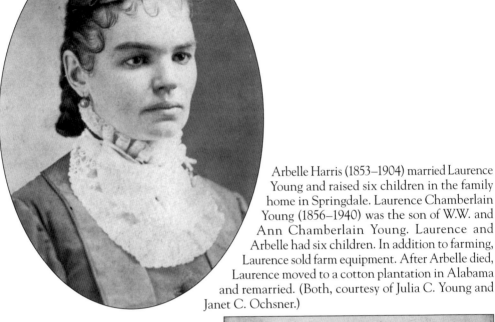

Arbelle Harris (1853–1904) married Laurence Young and raised six children in the family home in Springdale. Laurence Chamberlain Young (1856–1940) was the son of W.W. and Ann Chamberlain Young. Laurence and Arbelle had six children. In addition to farming, Laurence sold farm equipment. After Arbelle died, Laurence moved to a cotton plantation in Alabama and remarried. (Both, courtesy of Julia C. Young and Janet C. Ochsner.)

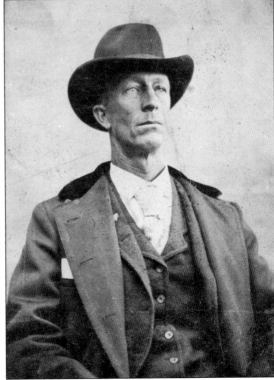

This was another Young family house, located opposite and west of Springdale Church. It was said that, for a brief time, one room housed the Springdale Post Office, run by "Grandma Young." One account says that, before it was Springdale, the village was called Iylersburg. Charles D. Iyler Jr. did own the tollhouse property at one time. (Courtesy of the H. Kiefer Maddox family.)

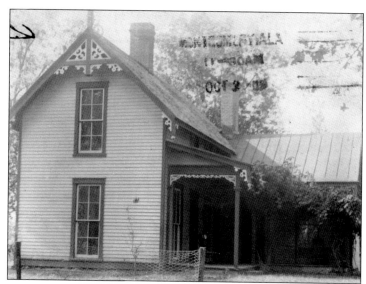

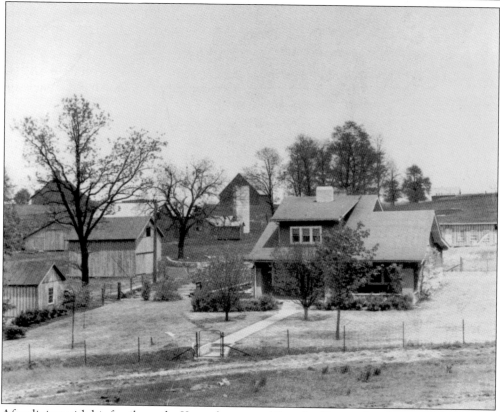

After living with his family on the Young homestead farm for 45 years, Laurence Young sold it to his brother-in-law, Landers Harris. Then, Xavier Schuler owned it until his death, when it was purchased by Henry Hahn. Hahn built a modern bungalow, pictured here, on the foundation of the original 1824 house and kept the spring under the house in its original configuration. Hahn had a noted dairy farm. The farm was purchased by the Standard Club around 1950. (Courtesy of the Standard Club.)

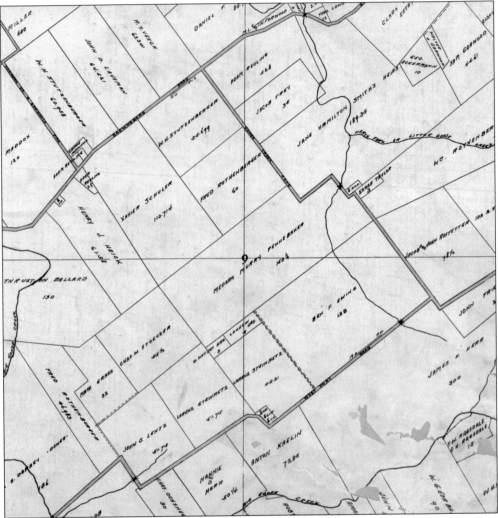

This map shows the Springdale community in 1913. Brownsboro Road runs diagonally across the top of the map, with Westport Road roughly parallel below it. Big Goose Creek is on the left, and Little Goose Creek on the right. What is now Barbour Lane was the Harrods Creek and Springdale Pike with the Adam Rueling commercial lots, later Nachands Grocery and Freibert's Garage, at the corner of Brownsboro Road. At the upper right corner of the map, where the road crosses Little Goose Creek, is the African American settlement known as Black Hills. Springdale Presbyterian Church is marked, as is the African American church, Goose Creek Church on Westport Road. Goose Creek School is on Goose Creek Road. By this date, the large land holdings of the Young family had been divided, with Thruston Ballard owning the part of the Young estate on Big Goose Creek that would become the 1931 estate of Harry Boone Porter, founder of Porter Paint Company, and his wife, Edith Robinson Wood Porter. It has been maintained as a large country estate that is actively farmed, with the landscape preserved. (Section from *Atlas of Louisville and Jefferson County, Kentucky*.)

Three

FOOD, FUEL, AND "ONE FOR THE ROAD"

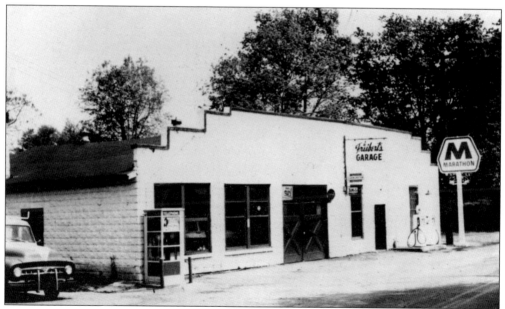

Around 1870, Adam Rueling, a German immigrant wagonmaker, opened a saloon, grocery, and blacksmith shop at Springdale. The blacksmith shop was one of the first businesses on the little commercial corner of Brownsboro Road and Barbour Lane. Rueling continued his wagon-making business with blacksmithing, woodworking, and striping work. His company made 20-barrel wagons—the only ones in the country built especially for potatoes. Joe Freibert constructed the building and opened a garage when he bought the blacksmith shop property around 1910. When automobiles came in, Joe was the only auto mechanic in the entire Worthington and Springdale area. When other farmers in the area were using mules, the nearby Sawyer farm, a model of modernity, bought tractors, which meant good business for Freibert's garage. (Courtesy of Richard Freibert.)

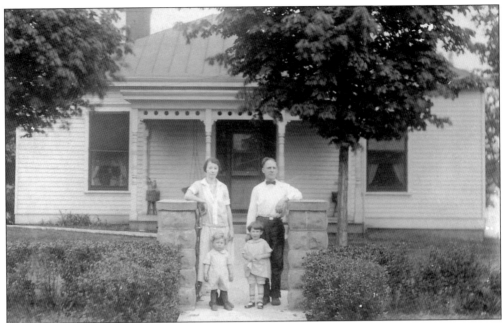

At the gate of their home on Brownsboro Road, Amelia and Joe Freibert and their children, Lucy and Joe, are shown in the early 1920s. Joe purchased the house when he bought the blacksmith property across the road in 1910. The house was built by Adam Rueling around 1902 on five acres across the road from his store and blacksmith shop. He purchased the land from the Young family, who had a large estate. The Springdale tollhouse was just to the west of the house. Lucy Freibert is a Sister of Charity, retired college professor, and noted feminist author and educator. (Courtesy of Richard Freibert.)

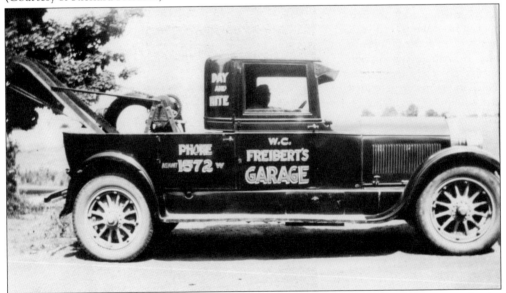

William C. "Bill" Freibert is shown at the wheel of his truck in the early 1930s soon after he purchased the business from his brother Joe. Bill ran the garage for many years with the help of his sons, who took over the business when Bill died. It was sold in the early 1960s, but the location remains an automotive center and service station. (Courtesy of Jeff Freibert.)

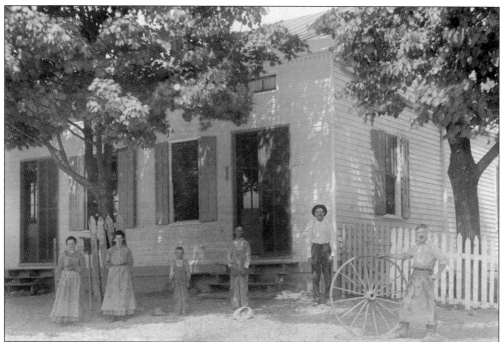

This building seen above was constructed by Adam Rueling about 1870. It was called Seven Mile House because of its distance from Louisville. When Rueling retired, his Nachand children and grandchildren moved from Westport Road and took over the business. The 1952 photograph at right was taken on the entry steps to Nachand's Grocery. Pictured are, from left to right, an unidentified woman, Mary Nachand, and her daughter, Oneda Nachand. The Nachand family ran the store until it was sold in the early 1960s. It stood on the corner of what is now Barbour Lane, which had been the original entry drive to the Barbour house. The 1879 map shows a blacksmith shop, a gristmill, and a tavern at this location. The corner remains commercial. (Both, courtesy of the H. Kiefer Maddox family.)

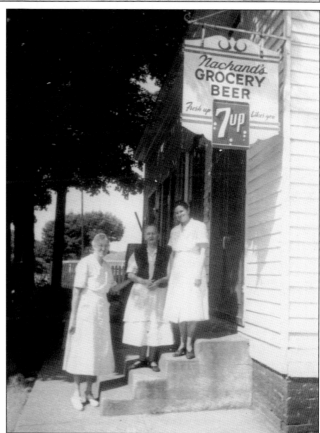

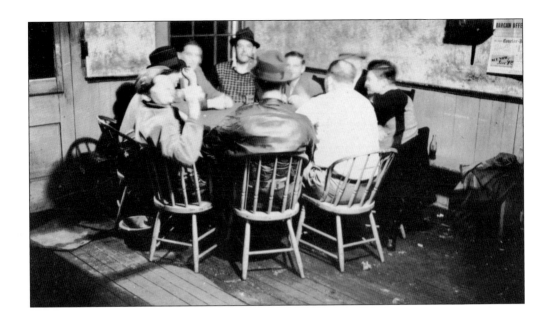

Often, an evening's entertainment meant meeting friends at the bar at Nachand's Grocery. Here, some of the local men enjoy a card game. The store building was also home to the Rueling and, later, Nachand families. Below, Peter Nachand and Mary Margaret Rueling Nachand pose at the gate to their home behind Nachand's Grocery around 1925. Mary Margaret's father was Adam Rueling, who emigrated from Germany about 1851 and established a grocery/saloon and blacksmith shop at this location on Brownsboro Road. (Both, courtesy of the H. Kiefer Maddox family.)

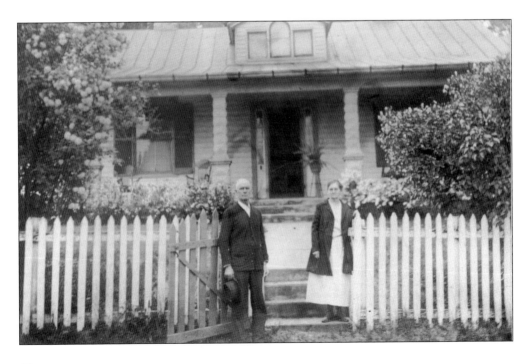

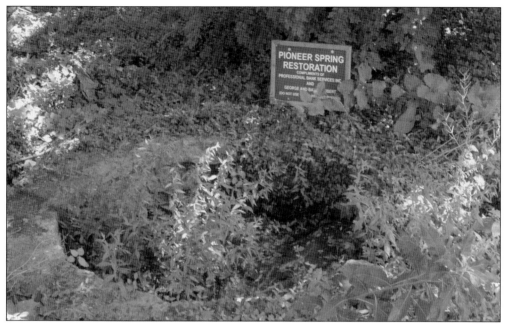

Around 1825, the Chamberlain family established a blacksmith shop beside the spring where Chamberlain Lane makes a right-angle turn to the east. The historic Shop Spring, as it is known, was restored and marked with a sign that reads "Pioneer Spring Restoration compliments of Professional Bank Services Inc. and George and Babs Freibert." The photograph below is thought to show the shop at the spring. Pictured, from left to right, are Albert Chamberlain, Edward Chamberlain, and ? McCarthy. (Above, 2014 photograph by the author; below, courtesy of Ann H. Chamberlain.)

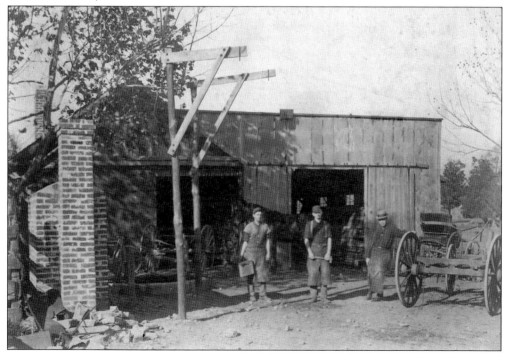

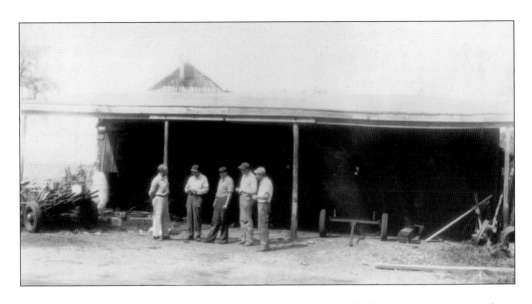

In the 1870s, John and William H.H. Chamberlain moved the blacksmith shop to Brownsboro Road at the northeast corner of Chamberlain Lane. Later, it was operated by William's sons, Ed "Tetel" and Albert, and the shop, along with the garage, was operated by Tetel's s sons Carl, Stanley, and Marion. The shop was located just east of the garage. Pictured in front of the shop are, from left to right, Harry Chamberlain and the four Chamberlain brothers—Russell, Carl, Stanley, and Marion. Below, the grandfather of the four Chamberlain brothers, William Henry Harrison Chamberlain, was photographed with his wife, Lucy Ellen Toler Chamberlain, and grandson William Gardner Chamberlain. (Both, courtesy of Clara Chamberlain Cruikshank.)

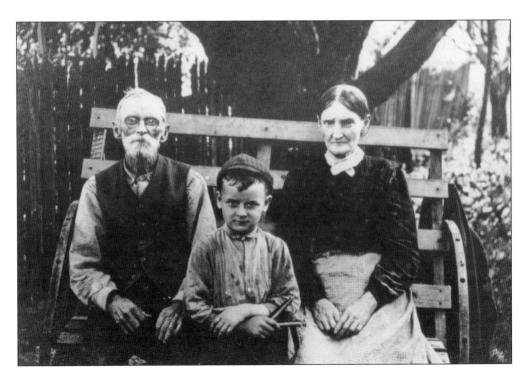

This 1928 photograph with a view looking east on Brownsboro Road shows the oldest version of the building on the corner that became the garage. The blacksmith shop is in the background. The sign on the side of the building reads "Worthington Garage Repairs Gas Oil." (Courtesy of Archives and Special Collections, University of Louisville, Caufield & Shook Collection.)

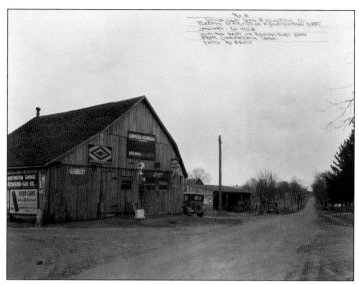

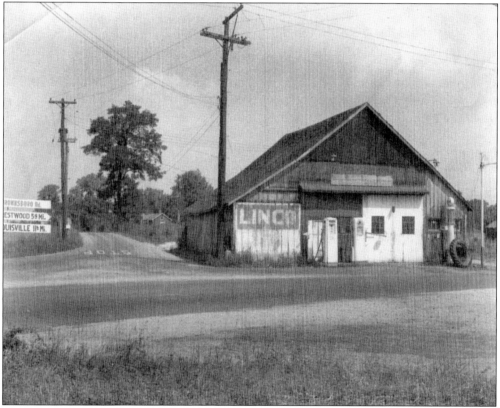

The location of Worthington Garage could not be any closer to Chamberlain Lane on the left and Brownsboro Road in front. The garage is shown here in 1947 and looked pretty much the same when it was demolished for widening of the road in 1969. In the background is the home of Ed "Tetel" and Mildred Chamberlain, which was built on the site of an 1847 schoolhouse. The handmade sign on the left reads "Brownsboro Road, Crestwood 5 1/2 Miles, Louisville 11 1/2 Miles." (Photograph by Frank Von Allmen, courtesy of Ann H. Chamberlain.)

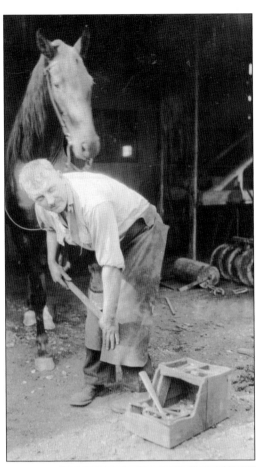

Ed "Tetel" Chamberlain is pictured shoeing a horse at the blacksmith shop. The Chamberlain Brothers advertise "Practical Horseshoeing" on their advertising card, which probably dates from the 1930s. (Left, courtesy of Clara Chamberlain Cruikshank; below, courtesy of Mildred Chamberlain Yochim.)

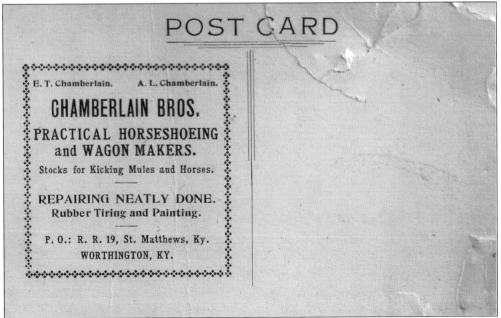

POST CARD

E. T. Chamberlain. A. L. Chamberlain.

CHAMBERLAIN BROS.

PRACTICAL HORSESHOEING
and WAGON MAKERS.

Stocks for Kicking Mules and Horses.

REPAIRING NEATLY DONE.
Rubber Tiring and Painting.

P. O.: R. R. 19, St. Matthews, Ky.
WORTHINGTON, KY.

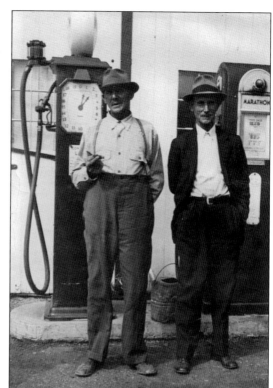

The garage was a popular spot for the "old-timers." Here, in front of the gas pumps, are C.H. Brenner (left) and Noah Maddox around 1940. Maddox was the father-in-law of garage proprietor Carl Chamberlain. Even the youngest men were photographed in front of the garage, such as Chris Zeitz around 1940. (Right, courtesy of the Brenner family; below, courtesy of Chris Zeitz.)

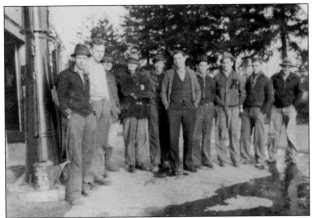

Worthington Garage was also a gathering spot for the young men of Worthington. The evergreen trees at the front of the cemetery are visible in the background. Posing beside the gas pumps are, from left to right, Peyton "Gil" Quinn, Stanley Chamberlain, Noah Maddox, unidentified, Carl Chamberlain, Edward "Bud" Zeitz, Harold Getling, Hymus Sims, unidentified, and ? Claxton. (Courtesy of Ann H. Chamberlain.)

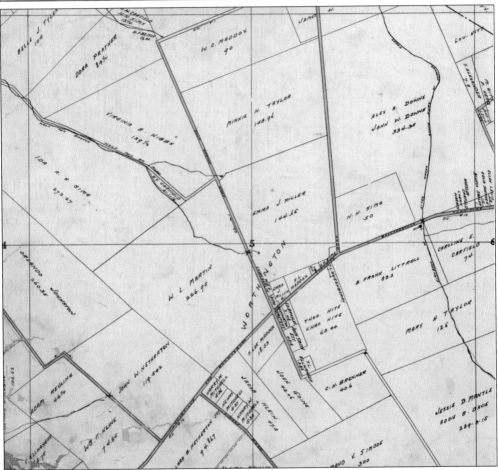

This map section shows Brownsboro Road running diagonally across the lower right corner of the map and turning north at the Sims property where the grocery was located. The small lots on the northeast corner of Chamberlain Lane (Shop Spring Road) and Brownsboro Road are the location of the blacksmith shop and garage. The school would be built on the Netherton property. The farm acreage is noted below the names of the owners. (Section from *Atlas of Louisville and Jefferson County, Kentucky.*)

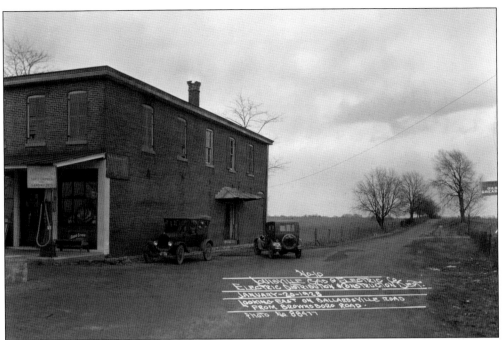

Worthington Grocery was constructed by H.H. Sims in 1888 with brick from the old Lakeland brick kiln. Sims ran the store until 1920. The sign in this 1928 photograph reads " W.B. Markwell, Soft Drinks and Sandwiches." There was a hall on the second floor accessed by the doorway on the south side of the building. In the 1870s, a post office was established at the store. This letter, dated 1885, shows the Worthington postmark. According to local oral history, the establishment of the post office prompted the naming of Worthington after the scion of a prominent local family. The photograph was taken to document a road repair project, so the view of the Ballardsville Road looking east—not the building—is the subject. (Above, courtesy of Archives and Special Collections, University of Louisville, Caufield & Shook Collection; below, courtesy of the Brenner family.)

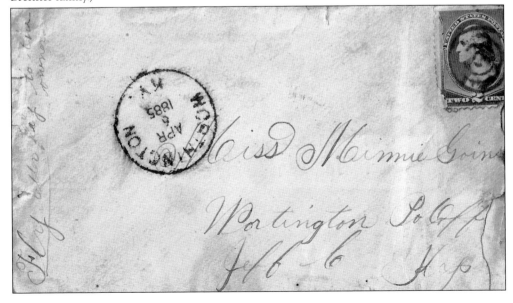

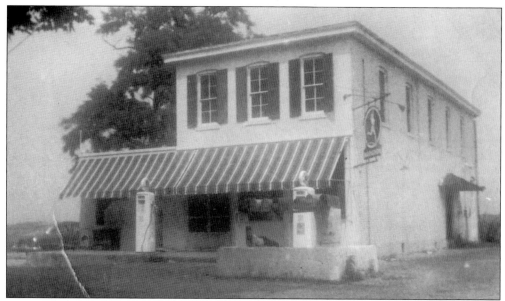

Burt Gottbrath and Evelyn Schuler Gottbrath purchased the grocery business in 1938 and built the single-story addition to the northwest side of the building in the late 1940s. The bar, which was a neighborhood gathering place at lunchtime and after work, was moved to the new addition. This view of Worthington grocery was taken after it was remodeled in 1955. Visible in the foreground is the concrete block wall that enclosed the well pump and was used as a mailbox platform. The post office that was originally in the store closed in the early 1900s, and the area received rural delivery from St. Matthews. The locals saw their first automobile when the mail was delivered by John Zoeller in a single-cylinder vehicle. (Courtesy of Gene Gottbrath.)

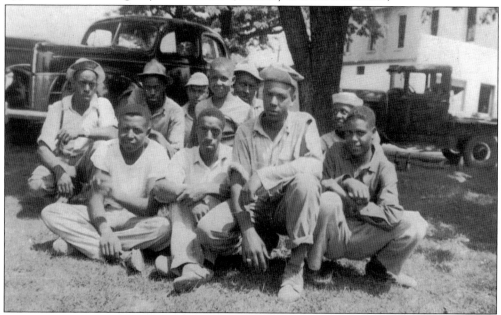

Farmworkers bought sandwiches and drinks in the grocery and ate their lunch in the shady Gottbrath yard across the road. These are most likely workers hired for the potato crop in the early 1950s. (Courtesy of Judith Gottbrath Schliessmann.)

Storekeeper Evelyn Gottbrath poses in front of the meat case and bread rack in this c. 1950 photograph. A display of garden seeds is behind her along with some of the variety of merchandise for sale. Bert Gottbrath was the store butcher and took pride in his home-cured country hams and sausage. On the rear wall is the enclosure for the stairs to the second-floor hall, which had an outside entrance. (Courtesy of Gene Gottbrath.)

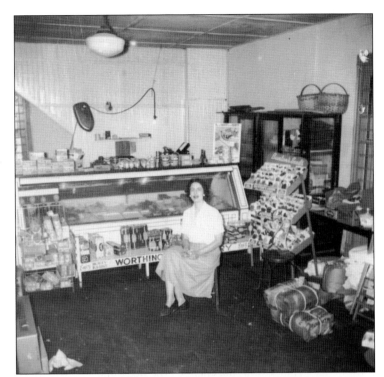

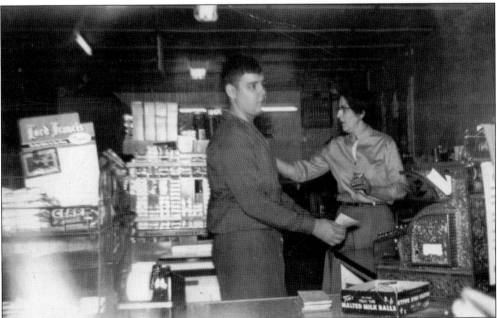

Although called Worthington Grocery, it was truly a general store. The business sold nails, clothing, oil-lamp shades, and cattle feed that came in flower-print 100-pound bags. After the feed was used, women turned them into "feed sack" dresses, aprons, dish towels, and so forth. Here, Evelyn Gottbrath supervises her nephew Ronnie Kaelin at the checkout counter in the early 1950s. The National Cash Register machine was original to the store and was used until it broke in 1956. (Courtesy of Gene Gottbrath.)

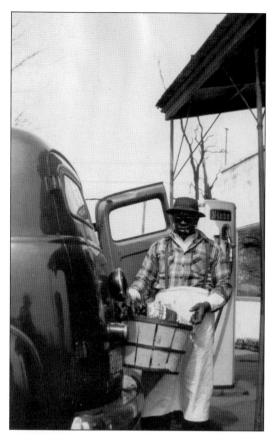

Worthington Grocery delivered groceries in the neighborhood on Saturday mornings. Bert Gottbrath would call customers, take their orders, and make the deliveries. Deliveries were made to the early subdivisions of Ten Broeck and Barbourmeade and a country route on Brownsboro Road and Covered Bridge Road. Here, George Lewis is loading the truck for delivery. In addition to grocery shopping, customers could also fill their gas tank at Worthington Grocery. Standing in front of the gas pumps are, from left to right, Dallas Ann Sandefur, Lewis, and Gene Gottbrath. (Both, courtesy of Judith Gottbrath Schliessmann.)

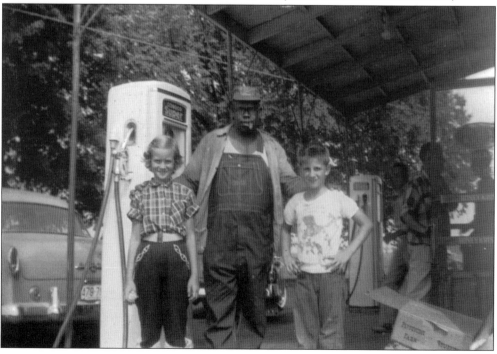

After 25 years, Bert and Evelyn Gottbrath retired from the grocery business in 1961. Their home, which was the original tollhouse, is in the background. In the distance is the family home of H.H. Sims, who built the grocery in 1888. The old Worthington Grocery building had been vacant for some time when it was destroyed by a 1970 tornado that also damaged several homes in the area. (Both, courtesy of Gene Gottbrath.)

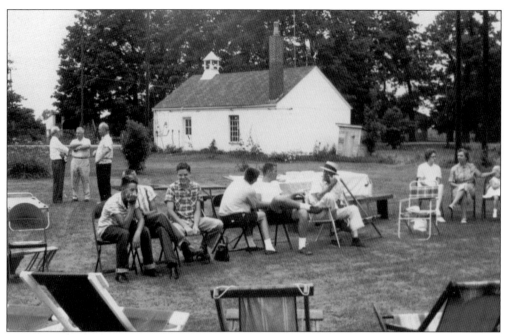

The Worthington Firehouse is in the background of this picnic in the Gottbrath family backyard. Fire department volunteers built the first firehouse, a small cement-block structure, on Brownsboro Road for $954.55. Organized at a meeting of about 60 local residents in the fall of 1943, the Worthington Fire Department has served the community for over 70 years. Until 1992, the fire department was a volunteer effort made up of community members. During that first year, the volunteers made eight fire runs. The area serviced by the fire department was located within a three-mile radius from the intersection of Brownsboro Road and Ballardsville Road. In the early 1960s, a second firehouse was built at Brownsboro and Goose Creek Roads. (Courtesy of Gene Gottbrath.)

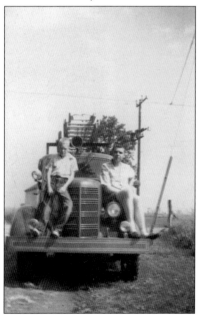

Larry Chamberlain (right) and Ronnie Kaelin (left) pose on the Worthington Fire Department truck. It was an army surplus vehicle and the department's second truck. The department paid $425 for the first truck, which was a wrecked Oertel's '92 beer delivery truck. The cab of the truck had been crushed, so the men cut it off and had an open cab. It had a water tank on the back and pulled an army surplus portable pump on a trailer. (Courtesy of Gene Gottbrath.)

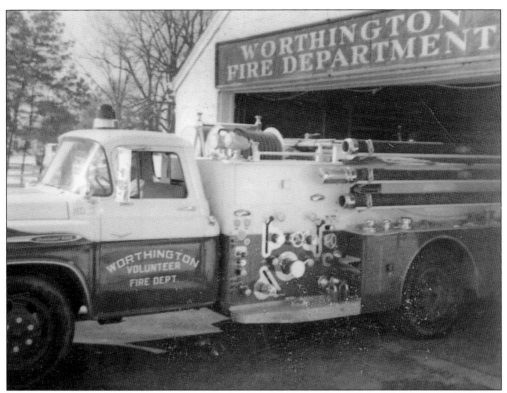

Pictured at the firehouse, this was the Worthington Fire Department's first "built" fire truck. The truck was purchased from Morehead Chevrolet in Crestwood around 1956. Stanley Chamberlain and Simeon Davis drove it to American LaFrance in Elmira, New York, where it was customized as a fire truck.

The first fire chief was Carl Chamberlain, proprietor of the Worthington Garage, shown here in 1975. Responding to a fire call at his home, Carl would continuously blow his truck horn to alert volunteers along his route to the firehouse. When he got there, Carl sounded the siren and sped away in the fire truck. Volunteers came from all directions, following the sound of the truck siren. Laying hoses to the nearest water source, they did their best to save their neighbors' homes. (Courtesy of Clara Chamberlain Cruikshank.)

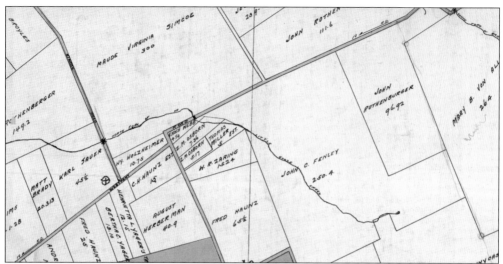

This section of the 1913 atlas shows Westport Road intersecting with Simcoe Lane and Fry's Hill Road. Fry's Hill is designated, as is the north fork of Little Goose Creek. (Section from *Atlas of Louisville and Jefferson County, Kentucky*.)

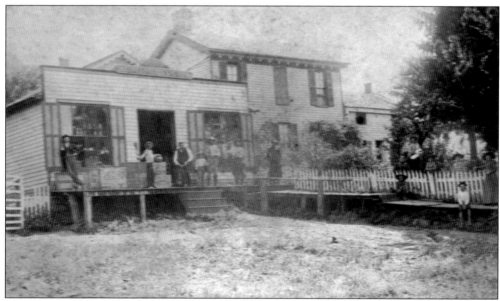

This photograph from around 1900 shows the general store at Fry's Hill—Gus Heinz, Groceries, Dry Goods, and Notions. Heinz, seated at the door, was a German immigrant, and brother of Mary Heinz Brenner. Christian Brenner and his wife, Mary, owned the four acres where the home and store were located. The Fry's Hill settlement is named for the original owner, Abraham Fry. There was a blacksmith shop located here as early as 1858, and the Farmers and Drovers Bank was across Westport Road. After Heinz died, his niece, Bettie Brenner Webb, and her husband, Enoch "Tom" Webb, took over the store and lived in the Brenner house with their sons, Hardin and William. (Courtesy of the Brenner family.)

This is the earliest photograph of the Fry's Hill house after the Brenners purchased it in 1864. The four-and-a-half-acre lot and house were sold by Jacob Hite in 1847 with the admonition on the deed that it not be "sold or transferred to any person or persons to be a nuisance to the neighborhood, vis, a Tipling Shop or a house of ill fame." This suggests that it may have previously been a commercial property. (Courtesy of the Brenner family.)

The house began as a log structure and had additions through the years. This is the front of the house, facing the original Westport Road that passed in front on the north side. Early maps show the Fry's Hill settlement at the dogleg turn of Westport Road. Sometime in the early 1950s, Westport Road was straightened to pass behind the house and the dogleg taken out. (Courtesy of Louisville Metro Historic Landmarks & Preservation.)

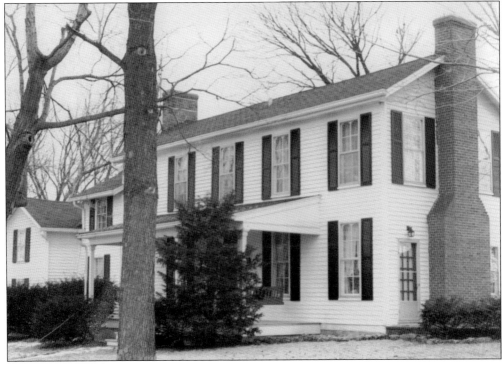

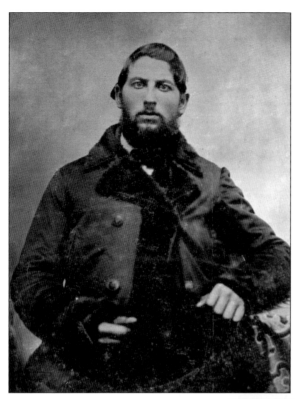

Christian Brenner (1830–1873) and Mary Elizabeth Heinz (1828–1895) were German immigrants who were married in 1855 and purchased the Fry's Hill property in 1864. Christian was a carpenter. (Both, courtesy of the Brenner family.)

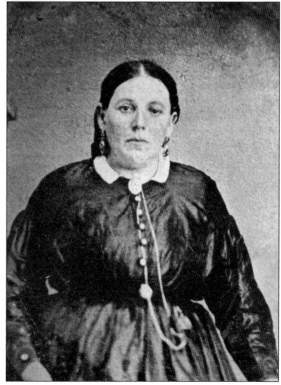

After the death of Bettie Webb's mother, Mary Elizabeth Heinz Brenner, her siblings sold the house to the Webbs in 1904. Bettie and Tom Webb are pictured with one of their sons, relaxing on the porch at Fry's Hill. The Webbs had two sons, Hardin and William. Both died at an early age from tuberculosis. (Courtesy of the Brenner family.)

Christopher Heinz Brenner, his wife, Minnie Goins Brenner, and children, Edward (on tricycle) and Mary Eliza, had a small home behind his parents' Fry's Hill residence. They are posing in their front yard about 1903. C.H. Brenner had purchased property at Fry's Hill in 1889 and 1901. When their third child, C. Bayless, was born in 1910, the family bought a home and farm on Chamberlain Lane. (Courtesy of the Brenner family.)

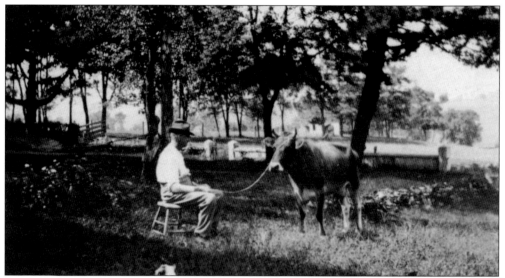

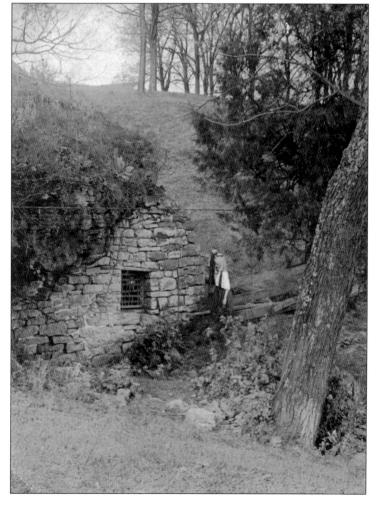

Tom Webb is posing with his cow in the front yard. The stone fence and entry gate were beside Westport Road when it passed north of the house. Edward F. "Felix" Brenner, son of artist Carl Brenner, was a photographer who liked to document the scenery around Fry's Hill and took this photograph. Another scene by Edward F. Brenner shows a young girl at a nearby springhouse. He titled the photograph *White Spring, Fry's Hill October 1915*. (Both, courtesy of the Brenner family.)

Four

FAMILY FARMS AND COUNTRY ESTATES

Emil Von Allmen was born in Switzerland in 1873, and his family immigrated to Louisville in 1883. In 1886, Emil's father, Frederick, opened a dairy business, where Emil learned the dairy business. He purchased the farm in 1919, and the dairy barns and bottling house were built between 1920 and 1940. The dairy remained in operation until 1964, when the construction of Interstate 71 and the Gene Snyder Freeway cut the farm into several tracts. In 1973, after 53 years in the Von Allmen family, the farm was sold. The barns were demolished and the house is now a restaurant. This image was taken by noted photographer Marian Post Wolcott (1910–1990) for the FSA Office of War Information Photograph Collection in 1940. (Courtesy of the Library of Congress.)

This is the Von Allmen Dairy farmhouse, built by William L. Martin, a broom manufacturer. Martin purchased the 226-acre tract (known as Egypt) from Dabney Strother "Boots" Taylor in 1911. Martin demolished the old Taylor house and built this brick home about 1912. Emil Von Allmen purchased the farm in 1919, and he and his wife, Arminta, and their family lived there until 1941. (Courtesy of Louisville Metro Historic Landmarks & Preservation)

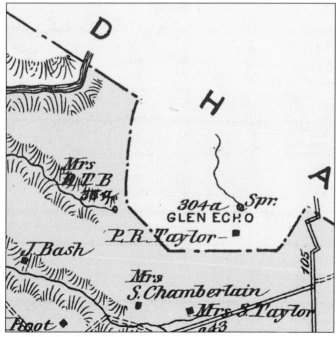

This section of the 1879 atlas illustrates the peculiar cut in the Jefferson–Oldham County line enclosing the Glen Echo farm (page 63). In 1874, the Kentucky General Assembly enacted that "the line dividing the counties of Jefferson and Oldham be so changed as to include within the county of Oldham the present residence and farm of Philip R. Taylor." The reason for Taylor's petition is unknown, but the line remains the same to this day. (Section from *Atlas of Jefferson and Oldham Counties, Kentucky*.)

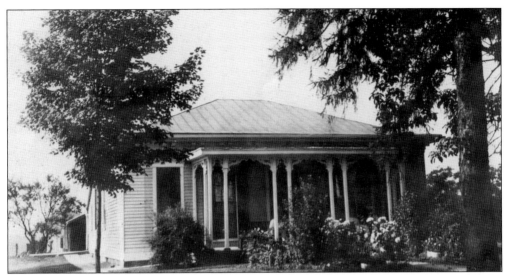

Before the Miller family bought their farm, it was called Glen Echo and was the home of Philip R. Taylor. Taylor has the distinction of moving the Jefferson–Oldham County line to make his farm in Oldham County (page 62). Taylor represented Oldham County in the state legislature in 1881 and served one term. The house was the family farm home for several generations of the Miller family. In this image, the Miller family is gathered on the farm around 1920. Pictured are (seated on ground) Eleanora; (seated) John F. Miller and Maggie Pauline Gabler Miller; (standing) from left to right, John Miller, Nannie Miller, Walter Miller, Caroline Singler Miller, and Henry Miller. The farm is now part of the Norton Commons development. (Both, courtesy of the Miller family.)

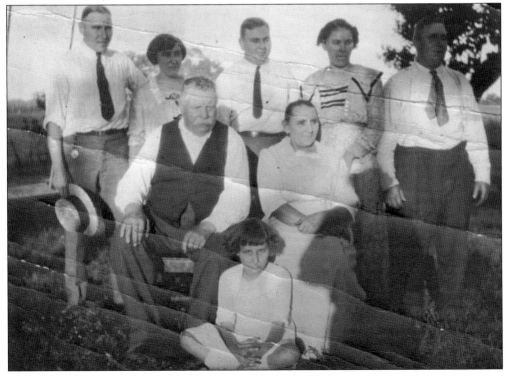

The William Rothenburger farm and home were on the west side of Simcoe Lane. The Rothenburger family is shown here on the steps of their home—from left to right, Louis, Maggie Hahn Rothenburger, Harry "Pete," Florence, and Rose. (Both, courtesy of Linda Rothenburger Siegrist.)

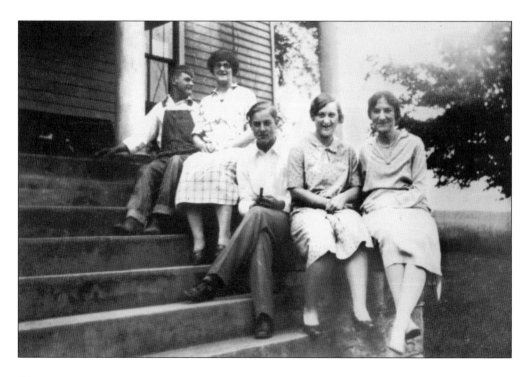

Robert Maddox was married to Addie Bell Young, who was the daughter of W.W. Young of the Springdale area. Addie Bell Young Maddox purchased the farm after her husband died. It was located on the east side of Brownsboro Road where the road runs north after it turns at Ballardsville Road. (Both, courtesy of Julia C. Young and Janet C. Ochsner.)

Before the Maddox family's ownership, this was the 300-plus-acre Downs farm. Addie Young Maddox moved to this farm about 1925, after her husband died. Her children—Larry Lee, Ruth, and Robert—grew up on the farm, and it remained in the family for many years. Below, hog butchering, or what the locals called "hog killin'," was an annual winter task for most local farmers. The whole family—and often neighbors—joined in, rendering lard, cleaning sausage casings, grinding sausage, and preparing the meat for the smokehouse. This photograph shows hog butchering on the Maddox farm in the 1920s. (Both, courtesy of Julia C. Young and Janet C. Ochsner.)

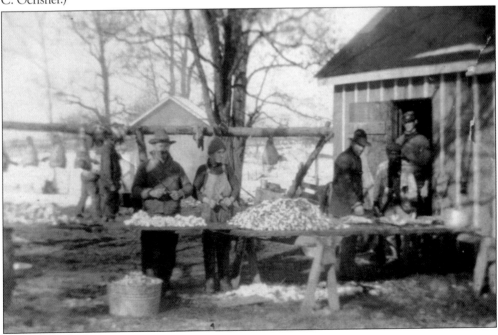

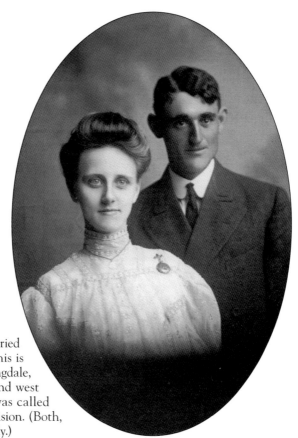

Charles Maddox and Lou Nachand married in 1907. He was 28 and she was 21. This is the barn on their 120-acre farm at Springdale, located north of Brownsboro Road and west of Barbour Lane. The farm, which was called Pinehurst, is now the Pinehurst subdivision. (Both, courtesy of the H. Kiefer Maddox family.)

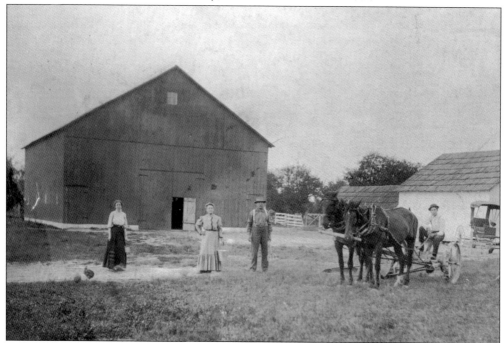

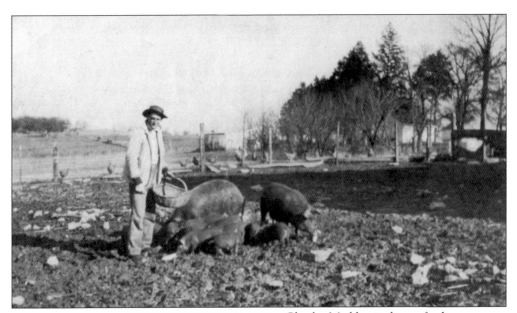

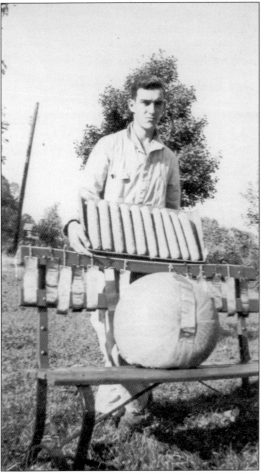

Charles Maddox is shown feeding hogs on his farm. Most of the local farmers raised hogs for their own use. At left, lifelong farmer Kiefer Maddox, the son of Charles and Lou Maddox, was interested in farming from an early age. In this picture, he shows his prizewinning corn and pumpkin with his state fair prize ribbons. (Both, courtesy of the H. Kiefer Maddox family.)

This is the Simcoe farmhouse, home of Newton and Clara Von Allmen Simcoe and their family, on Westport Road. The house was built in 1935 by Peter Von Allmen, and the Simcoes purchased the farm when the house was new. Newton's parents, Hewitt and Maude Simcoe, built a log house on the Westport Road farm in the late 1940s. When the farm was sold to the Ford Motor Company for the Kentucky Truck Plant in 1969, their granddaughter, Doris Simcoe Claiborne, had the log house moved to Wolf Pen Branch Road and made it her home for many years. (Both, courtesy of David Simcoe.)

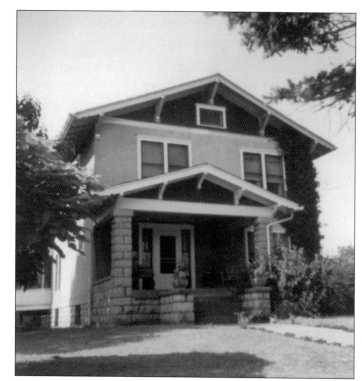

Newton Simcoe and Clara VonAllmen were married in 1922 and had four children—Mary Virginia, who died at age six, Richard, Doris, and David. In addition to the farm animals, the Simcoe farm on Westport Road was home to a variety of pets, including a long-lived parrot that Clara had since she was a girl. (Both, courtesy of Doris Simcoe Claiborne.)

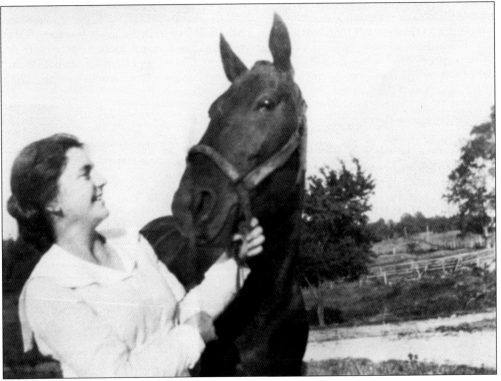

Ownership of the Zeitz farm can be traced to Charles S.W. Dorsey in the 1850s. It is identified on the 1879 map as Oaklands, the farm of General McClure. The farm was located on the south side of Brownsboro Road across from Worthington Grocery. Christy and Rosa Schoenbacher Zeitz are posing on the front porch of their farmhouse. They purchased the farm in the early 1900s. (Both, courtesy of Chris Zeitz.)

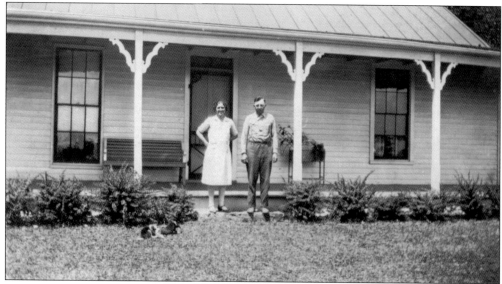

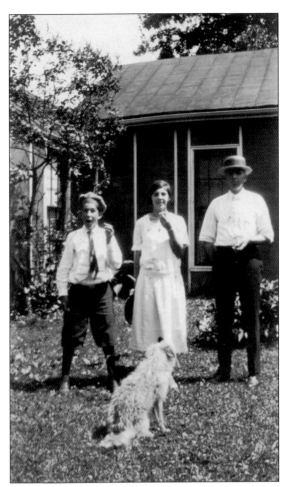

The Zeitzs raised their two children, Edward "Bud" and Edith (Littrell), on the farm. Pictured here are Christy Zeitz and his children, Bud and Edith, with their dog, Little Jack, about 1920. Below, when Bud Zeitz married, he built a house for his family on Brownsboro Road and spent his life working the family farm. Here are Bud, his wife, Alice, and son, Chris, outside their home about 1940. (Both, courtesy of Chris Zeitz.)

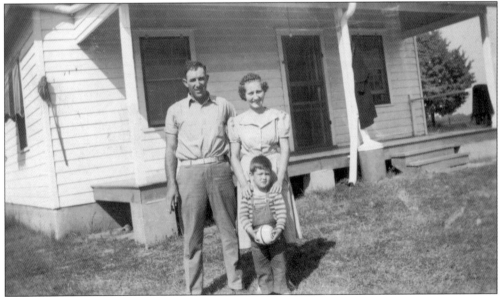

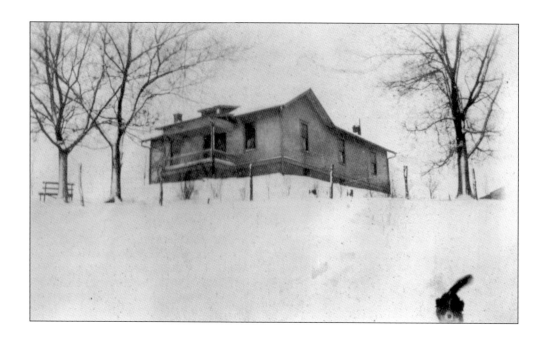

The Rupp farm was in the Springdale area on Barbour Lane. John Karl "Charlie" Rupp (1874–1942) and his wife, Katherine Rupp, purchased the farm around 1910. They raised their four children, John, Henry, Ernestine, and Florence, on their farm. Below, Charlie Rupp is shown here plowing with his mule team. The Rupp family continued to farm with mules after many local farmers began using tractors. The Rupp brothers, John and Henry, and their sister, Ernestine, continued to work their family farm after their parents died. Florence married Walter Miller and they lived on the Miller farm in Oldham County. (Both, courtesy of the Miller family.)

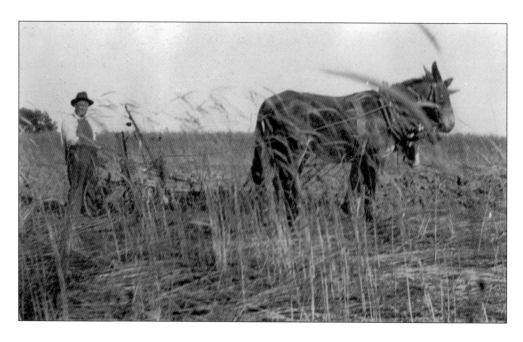

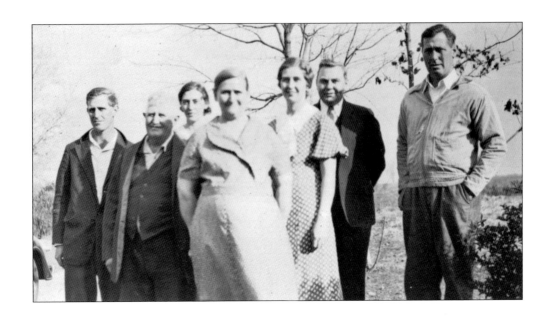

This photograph of the Charlie and Katherine Rupp family in the 1930s includes, from left to right, son John, Charlie, daughter Earnestine, Katherine, daughter Florence and her husband, Walter Miller, and son Henry. Below, an unidentified Rupp farmworker is unloading farm equipment from a truck. (Both, courtesy of the Miller family.)

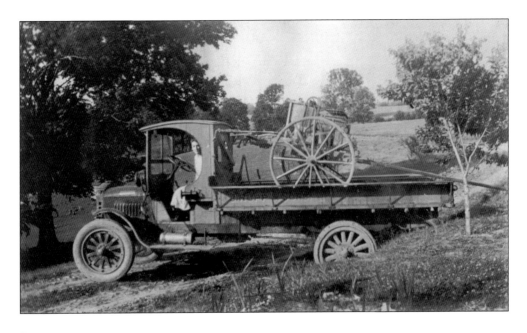

L. Ray and Martha Ellers purchased this home on Wolf Pen Branch Road from the Sims family in 1940. It was originally a frame house that was part of the D.S. "Boots" Taylor estate. The residence is said to date from the late 18th century, and was remodeled in the 1950s. The Ellers' daughter, Rosella Ellers Jaegers, married Kenny Jaegers, who was the manager of the farm, and the Jaegers family lived on the farm. Pictured at right, Dr. Lauren Ray Ellers was a well-known Louisville surgeon. He graduated from University of Louisville Medical School in 1914. (Both, courtesy of Gene and Kenny Jaegers.)

Johnny Head and Estelle Goins Head's farm was on the first turn of Chamberlain Lane, south of Brownsboro Road. It extended to both sides of Chamberlain Lane. This was part of the farm Estelle and her son, Bobby Head, inherited from John Goins, Estelle's adoptive father. This photograph of the Head house was taken from the adjacent Bayless Brenner home and shows one of the farm ponds. On the hill to the right of the house, Johnny and Estelle's son, Bobby, and his wife, Doris, built a house and raised a family while working on the family farm. (Courtesy of the Brenner family.)

The photograph of Bobby Head and his dog at the family mailbox is on the cover of a *Courier-Journal Rotogravure* from the late 1930s. Bobby was active in 4-H and raised prizewinning Angus steers. He continued working the family farm until the land became more valuable for development than for farming. (Courtesy of the Brenner family.)

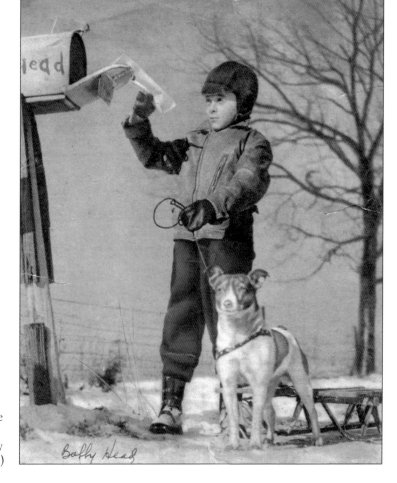

Chris Brenner and Minnie Goins Brenner purchased their farm on Chamberlain Lane in 1911. The house was probably built in the 1870s. Chris had worked selling farm equipment and the family lived at Fry's Hill. They began farming when they moved to this 40-acre property, which adjoined the Goins farm, where Minnie grew up. In addition to their farm, the Brenners rented and cultivated the Mantle farm. After Chris and Minnie died, their eldest son, Edward, lived in the family home and continued farming until his death in 1956. Below, Minnie is feeding her flock of turkeys on the Chamberlain Lane farm about 1935. (Above, courtesy of the Brenner family; below, courtesy of Mary Ann Roemer Reas and John J. Roemer.)

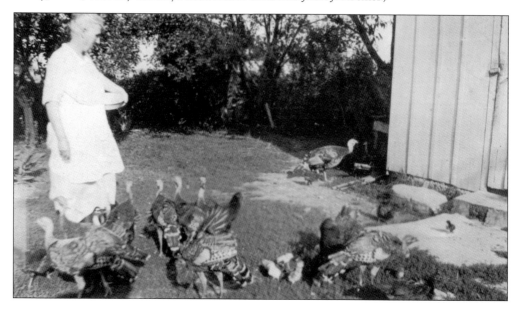

Bayless Brenner worked on the family farm until he married Thelma Rupp in 1934. They bought a small, three-room house on the east side of South Chamberlain Lane. He was a carpenter and remodeled many homes in Worthington, including his own, which had several renovations. Shown here about 1954 are, from left to right, Bayless, Thelma, Sharon, and Carol. The home now serves as a counseling center for Northeast Christian Church. (Courtesy of the Brenner family.)

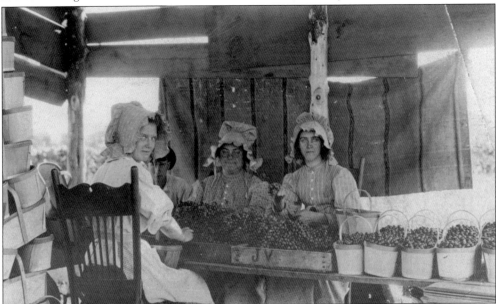

This photograph is titled *Grape Pickers on the Tyler Farm near Worthington*. It is the only known record of commercial grape cultivation in the area. The Tyler farm was off Wolf Pen Branch Road in 1913. The photograph was taken by Carlos Brenner, the son of noted Louisville artist Carl Brenner. (Courtesy of the Filson Historical Society.)

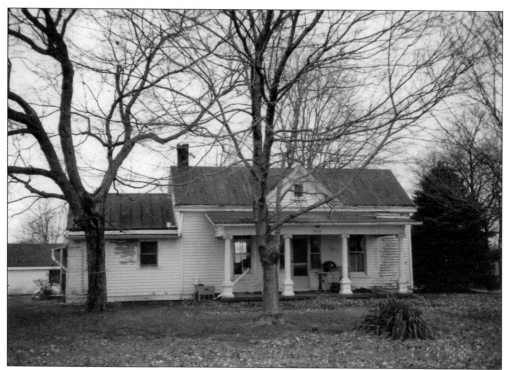

The Klein family first farmed on Springdale (Hoke) Lane, and Albert Klein later purchased his farm on the west side of Chamberlain Lain north of Brownsboro Road. Below, Eva and Albert Klein were active in the community, in addition to taking care of their farm. Eva was a 4-H leader, and both were active in Springdale Presbyterian Church. (Both, courtesy of Joyce Davis Shipley.)

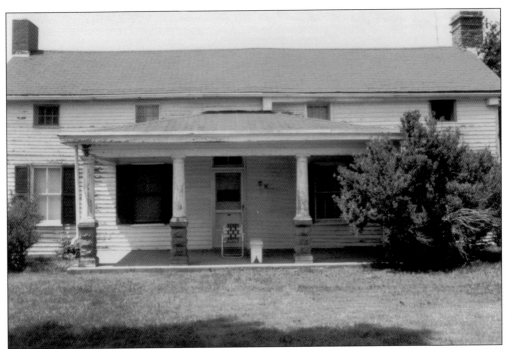

Located north of Brownsboro Road, on Chamberlain Lane, the WAVE farm was owned originally by the Fishback family, who were large landholders along the branch of the south fork of Harrods Creek. This house was the home of William Jefferson Fishback and his son, Edward. The Fishbacks were neighbors to the south of Reuben Taylor's family. Edward Fishback was noted as a cabinetmaker and expert woodworker, having made rifle stocks for some of the early western explorers. Fishback probably built the log section of the house in the early 1800s. In the 1950s, George Norton, owner of the WAVE radio and television stations, purchased the farm. It became a demonstration farm devoted to cattle raising and dairying and the site of University of Kentucky and Purdue University agricultural experiments. Beginning about 1955, Paxton Marshall, farm manager, was the host of a weekly TV show that was telecast on location at the WAVE farm. (Courtesy of Louisville Metro Historic Landmarks & Preservation.)

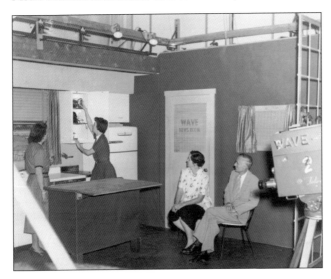

When the TV station wanted to air a cooking program, the WAVE farm manager's wife, Shirley Moser Marshall, with her degree in home economics, was the obvious choice. The WAVE -TV cooking show, *Flavor to Taste*, debuted in 1949, and continued five days a week, until 1957. It was one of the first televised cooking shows in the country. In this photograph of the set of *Flavor to Taste*, guest kitchen designers share design tips with show host Shirley Marshall (seated). (Courtesy of Shirley Moser Marshall.)

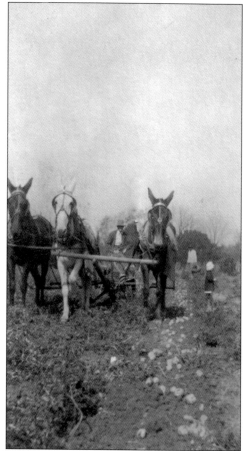

The soil on local farms was especially suited to growing potatoes, which were the primary crop for many of the farmers in Worthington and Springdale. Mules were used on the Maddox farm in 1918 to pull the potato digger. This turned up the potatoes so workers could gather them. The potato pickers can be seen with their baskets. A mule team was also more efficient for cultivating potatoes because the mules were better at going down a row than a wide tractor tire. Below, a beautiful sight with the promise of a bountiful crop, a field of potatoes is in bloom on the Zeitz farm. Farmers grew two crops of potatoes each year, planting one in February and one in July. (Right, courtesy of H. Kiefer Maddox family; below, courtesy of Chris Zeitz.)

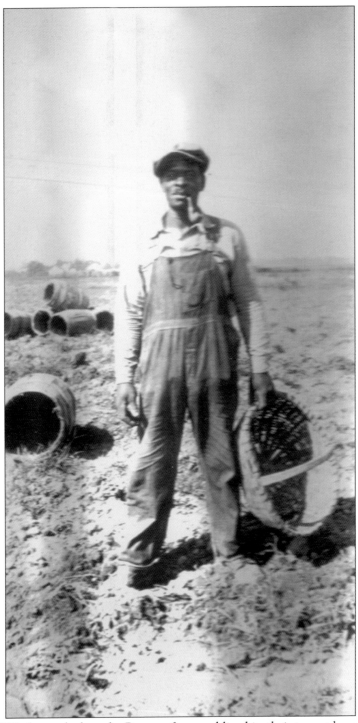

Dudley "Dud" Taylor worked on the Brenner farm and lived in their tenant house. Pictured in the potato field, Dud is posing with his potato baskets. Locals did not use words like "harvesting" or "gathering." It was always "picking up potatoes." It was backbreaking work. (Courtesy of the Brenner family.)

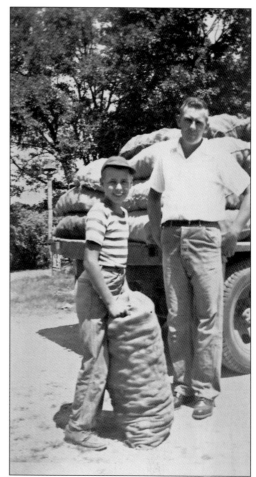

Ron Miller hefts a bag of potatoes while his brother, Walter, looks on. The bags weighed about 100 pounds. The photograph is from about 1950. Below, the Garwood family farmed several tracts in the Worthington area. Pictured here are unidentified workers harvesting potatoes on one of their farms. (Right, courtesy of the Miller family; below, courtesy of the Garwood family.)

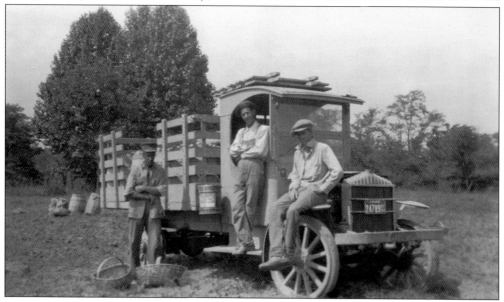

In 1916, the *Jeffersonian* newspaper announced that construction had begun on a potato grading and loading facility on property immediately south of Dr. Quesenberry's drugstore, office, and residence (later the home of Quesenberry's widow, Cecil, and her husband, Otis Sims) on the south side of Brownsboro Road at Worthington. The Worthington branch of the St. Matthews Produce Exchange enabled neighborhood farmers to shorten their hauling distance to market their potato crops, thus saving them time and expense. (Courtesy of Louisville Metro Historic Landmarks & Preservation.)

Fred Stutzenberger Sr. had, in a peak year, planted 70 acres of potatoes on his Brownsboro Road farm at Springdale. He was a vocal advocate for encouraging more people to eat Kentucky potatoes. In his obituary, Stutzenberger is quoted as having said, "People are eating less potatoes than they used to, because of diet propaganda. Potatoes actually aren't as fattening as other high protein foods." (Courtesy of Dr. Fred Stutzenberger.)

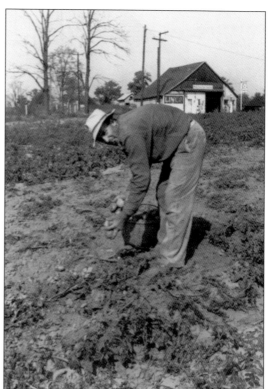

With the Worthington Garage in the background, Bud Zeitz and his wife, Alice, are picking up potatoes on land he rented on the corner of Chamberlain Lane and Brownsboro Road. In addition to cooking and housework, Alice Zeitz worked on the farm along with her husband and in-laws. (Both, courtesy of Chris Zeitz.)

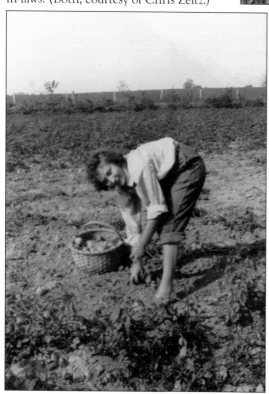

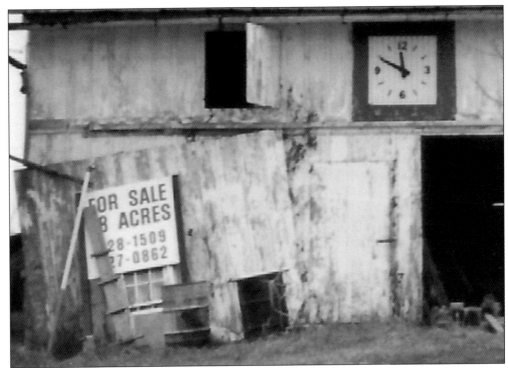

Time has run out for the farmers of Worthington and Springdale. The sign leaning against the Klein barn says it all. The Klein family farm was sold in 1998. Below, selling the family farm and a lifetime of memories, Bud Zeitz (in the center of the photograph) talks with bidders at the Zeitz farm auction in 1978. (Above, courtesy of Joyce Davis Shipley; below, courtesy of Chris Zeitz.)

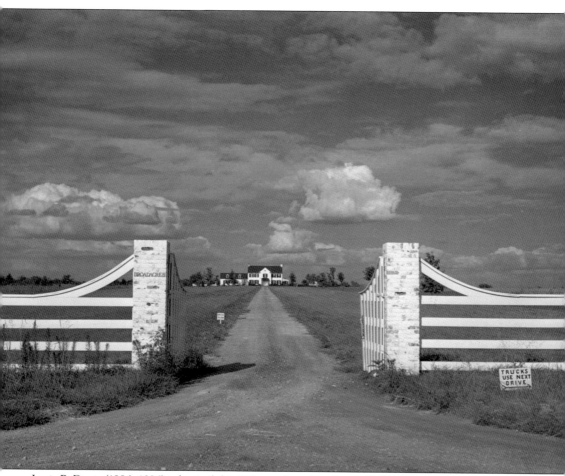

Jessie B. Davie (1886–1936) inherited this 240-acre farm from James Kalfus. The house was probably built about the time of her 1910 marriage to James Brown Mantle. Mantle was an executive with American Oak Leather Company in Louisville and rented his land to neighboring farmers. In 1917, the Mantles leased the farm to neighboring farmers C.H. Brenner and his brother-in-law, John Goins, for $1,200 per year. The very detailed lease includes painting and clearing the woodland, in addition to planting specific crops. Subsequent owners of the farm were the Kelly Young and the Hart families. This photograph was taken by noted photographer Marian Post Wolcott (1910–1990) for the FSA Office of War Information around 1940. (Courtesy of the Library of Congress.)

In 1932, another gentleman farmer, Lewis Kaye, purchased a farm on Springdale (formerly Hoke) Road that he called Cedarbrook Farm for the line of cedar trees that lead to the house. It was originally the Dr. Harbold farm, dating from the early 1800s. In 1940, Louisville architect Fred Elswick used stone and salvaged paneling from a 1796 house in Vevay, Indiana, to enclose the original 1860s Harbold house. Lewis Kaye was a banker and owned two large stock farms in addition to Cedarbrook Farm. (Courtesy of Louisville Metro Historic Landmarks & Preservation.)

Fred and Norma Nagel built this house in 1938 and raised their two sons here. Nagel was the owner of Tri-State Cornice and Roofing Company. The Nagels owned several farm tracts that they rented to neighborhood farmers. This is now the clubhouse for the Cobblestone Estates patio homes that surround it. (Photograph by the author.)

Five

Country Schools, from One Room to Three

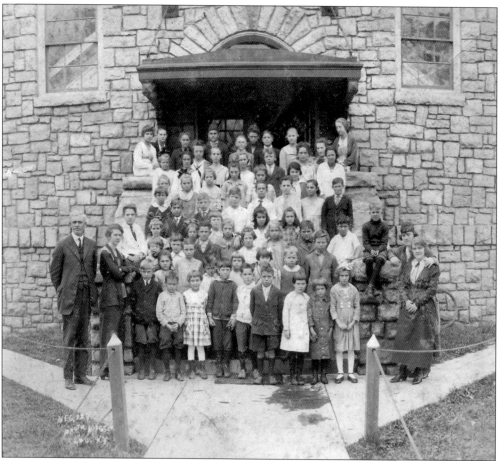

This photograph of Worthington School students was taken about 1920. The children who have been identified are Eleanora Miller (first row, third from left, plaid dress), Bayless Brenner (third row, third from left, dark jacket, buttoned collar), Harry "Pete" Rothenburger (seated on the right stone stair rail, wearing knickers and long stockings), and ? Steinmetz (fifth row, center, with tie). To his right are his brother and sister. The two adults on the left are ? Napier and Jane Hite, and the woman on the right is ? Beeler. (Courtesy of the Brenner family.)

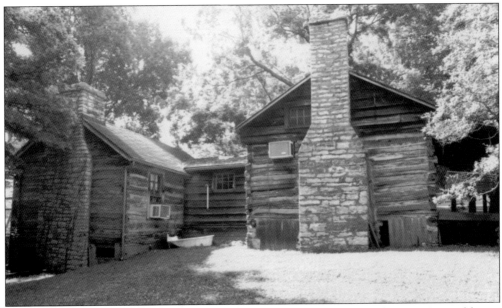

The rear cabin (left) was said to have been the oldest schoolhouse in the area. Legend has it that Pres. Zachary Taylor (1784–1850) attended this school when he was a boy. This complex of cabins has been moved from other places on the property, which was the original Dr. Harbold farm. (Courtesy of Louisville Metro Historic Landmarks & Preservation.)

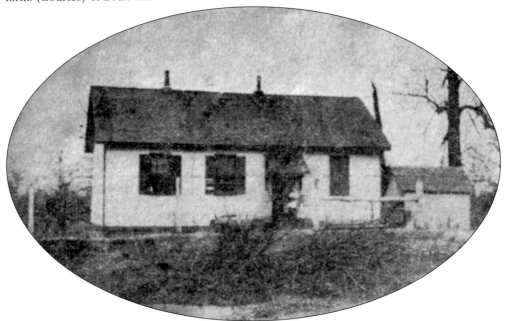

There are few photographs of the early one-room schools in the neighborhood. This is the Goose Creek School, which served the Springdale area. It was located on Goose Creek Road and burned in 1936. Dating to 1847, the school on Chamberlain Lane burned around 1856. The Chamberlain family home was built on this site. Another early school, Cherry Valley School, was off Wolf Pen Branch Road. School was held in the 1824 Wesley Chapel church building located near Haunz Lane in Oldham County. (Courtesy of Julia C. Young and Janet C. Ochsner.)

The Rock Bridge School was probably built in the 1850s to replace some of the smaller schools. It was on Ballardsville Road on the west side of Fishback (Hite) Creek and served the neighborhood until Worthington Consolidated School was built in 1915. Rock Bridge School became Worthington Colored School, and was the last one-room, one-teacher school in Jefferson County when it closed in 1958 with the integration of the county schools. (Courtesy of Gene Gottbrath.)

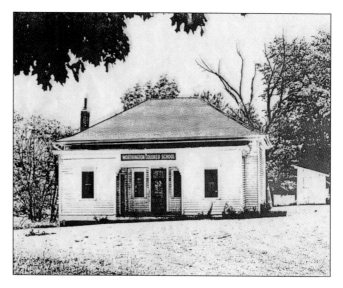

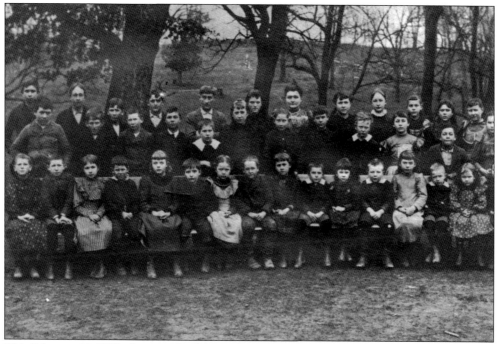

This February 14, 1895, photograph of the students of Rock Bridge School shows 40 students and one teacher. Pictured are, from left to right, (first row) Susie Chamberlain, Jon Claxon, Agatha Schuler, Freddy Rothenberger, Georgia Baisch, Ernest Schumate, Annie Miller, Alex Downs, Annie Rothenberger, Guy Wheeler, Lizzie Claxon, Roy Pinnell, Mayme Miller, Buzz Wheeler, Susie Downs, Albert Chamberlain, and Hallie Brown; (second row) John Rothenberger, Jim Maddox, Will Claxon, John Fourtman, Ollie Best, Finie Miller, Floyd Pound, Deanie Rothenberger, Joe Miller, Fannie Miller, Tommie Maddox, and Maude Claxon; (third row) Ed Schuler, John Downs, Galt Claxon, Charlie Maddox, John Best, Mamie Chamberlain, Miss Tea Hays (teacher), Mae Williams, Elsie Downs, Mary Pounds, Maggie Rothenberger, and Minnie Pound. (Courtesy of Gene Gottbrath.)

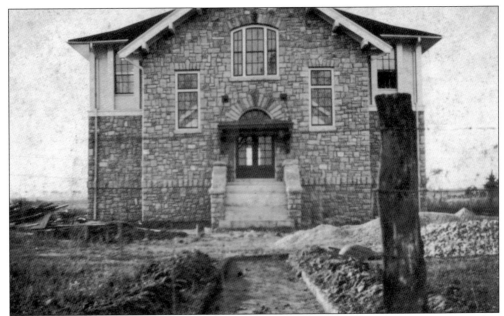

In this c. 1914 photograph, the new Worthington School is under construction. Henry Frank, a Middletown builder, constructed the building from stone that was quarried and hauled by community farmers. The land for the school was donated by John W. Netherton. When the new school opened in 1915, the students walked in procession from the old Rock Bridge School. Over 40 years later, in 1959, the school was closed, and the children and teachers were sent to Zachary Taylor Elementary on Westport Road. (Courtesy of the Brenner family.)

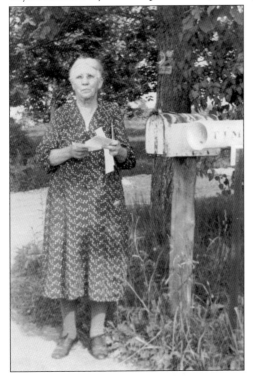

Minnie Goins Brenner, shown here at her mailbox, was elected president of the Mothers League of Worthington School, which was organized in 1917 with 18 members. The group met monthly and sponsored a flag raising and picnic on the Fourth of July with a ball game to follow. It also had fundraising parties, like the box party that raised $40 in October 1917. (Courtesy of Mary Ann Roemer Reas and John Roemer.)

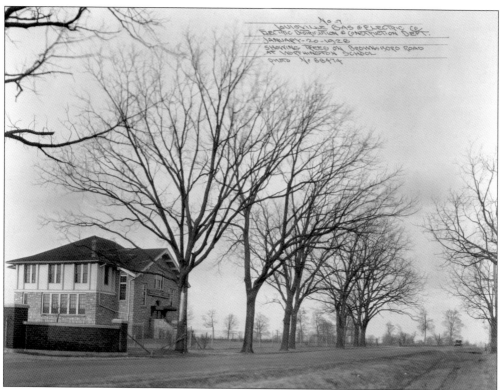

This 1928 view of Worthington School is looking east on Brownsboro Road. The row of trees and the open landscape show the school's rural location. The brick gateway on the left marks the entry to the John W. Netherton home. Netherton donated the land for the school. (Courtesy of Archives and Special Collections, University of Louisville, Caufield & Shook Collection.)

The new schoolhouse, with its auditorium space, replaced Sims Hall for entertainments and events, like the 1917 political rally advertised here. An August 1917 newspaper reported that an entertainment at the schoolhouse, made possible with donated electric lights, attracted the largest crowds in the school auditorium to date. Later that year, a minstrel show made about $15, which would be used for installing a Delco light at the school. About 40 years later, the Worthington Community Players presented a minstrel show, which sold over 500 tickets. (Courtesy of the Brenner family.)

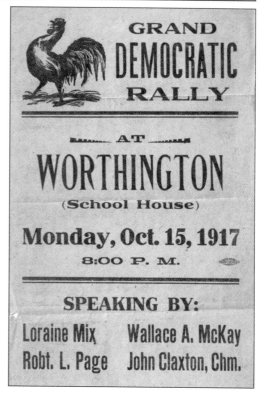

Jane Glass Hite (1892–1989) was a popular teacher at Worthington School. Hite was a direct descendent of one of the Hite family who explored and surveyed the Harrods Creek area in 1775. The Hite land holdings extended from Westport Road to La Grange Road. Named Lakeland for the lake on the property, it became the home of Central State Hospital. The E.P. "Tom" Sawyer State Park is on the former Hite estate. (Courtesy of the Heick family.)

Cecil Funk Quesenberrry Sims (1891–1979) was known to generations of Worthington School children as "Miss Cecil." She was married first to Dr. Quesenberrry (1859–1922), whose office, drugstore, and home were on Brownsboro Road, just west of the Worthington Grocery. Her second husband was Richard Otis Sims, and they lived in the Quesenberrry house. Miss Cecil was quite energetic and walked about a mile each way to school every day. She began teaching when she was 18 years old in 1909, and came to Worthington School in 1918. She taught the first and second grades until she retired in 1949.

The "Worthington Blues" boys' basketball team got most of the attention in the press; however, the school proudly sponsored a team for girls as well. In their bloomer and middy uniforms with the embroidered "W" for Worthington are, from left to right (first row) Alberta Netherton, Clara Mae Netherton, and Clara Von Allmen; (second row) Rose Rothenberger, Mary Franz, Marie Von Allmen, and Ellis Powers (coach). (Courtesy of David Simcoe.)

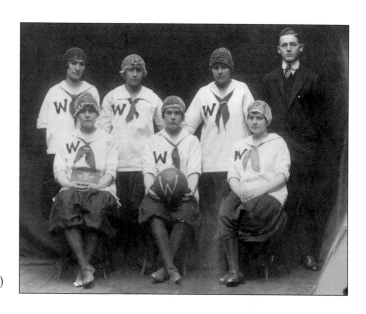

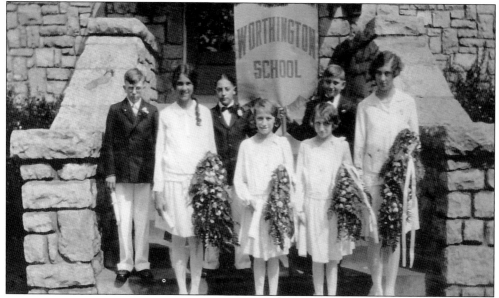

An eighth-grade graduating class displays a school banner. All of the eighth-grade classes in the county graduated together, so the banner was carried in procession to identify the school. From 1915 to 1919, the school included two high school grades, but they were dropped and students attended high school at Anchorage or at schools in Louisville. The school went through the eighth grade until 1950, when Eastern High School was built for both junior and senior high. Then, Worthington had six grades, with two grades in each of the three classrooms. (Courtesy of Ann H. Chamberlain.)

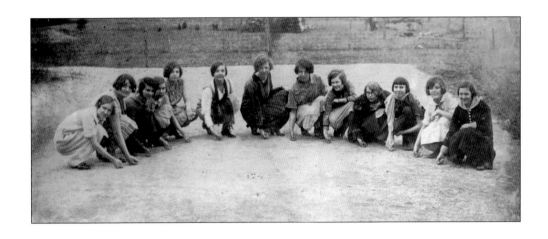

Around 1925, the *Courier-Journal* sponsored a countywide marble playing championship. The newspaper sent photographers to the elementary schools to photograph their teams. The photograph of the Worthington girls' team includes, from left to right, Katherine Markwell, Mary Alice Largin, Clarine Wright, Eleanora Miller, Edwina Schuler, Margaret Head, Jane Hite (teacher), Ollie May Wheeler, Nellie Stoess, Nellie Miller, Muriel Claxton, Ruth Garwood, and Oneda Largin. The image of the Worthington boys' marble team includes, from left to right, William "Billy" Doyle, Russell E. Chamberlain, Clifford "Chippy" Lausman, Walter Markwell, Emil Lausman, Henry Heick, and William S. "Bill" Garwood. (Above, courtesy of Ann H. Chamberlain; below, courtesy of the Garwood family.)

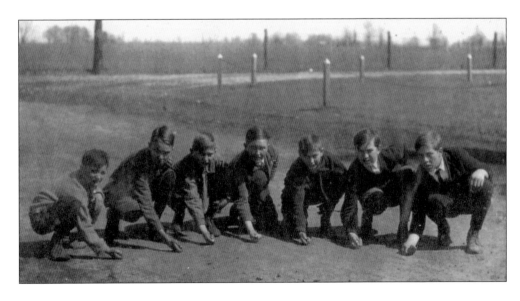

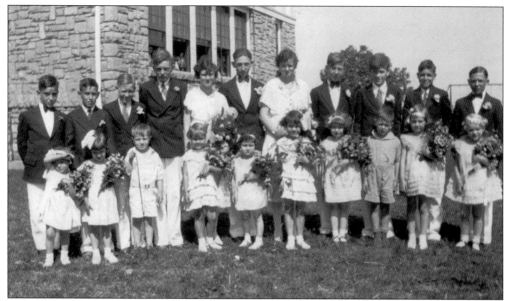

The 1931 Worthington School eighth-grade graduating class is pictured with the first-grade children in attendance. Mary Virginia Simcoe, daughter of Newton and Clara Simcoe, is second from right in the first row. Sadly, she died soon after this photograph was taken. (Courtesy of Doris Simcoe Claiborne.)

Worthington School did not have nursery school or kindergarten in 1945, but if it had, these children would probably have attended. Pictured are, from left to right, Sharon Brenner, Linda Wallace, Winston Chamberlain, unidentified Clifton boy, Barbara Edwards, Judith Gottbrath, and Carol Brenner. Winston, Barbara, Judith, and Carol would go through Worthington School in the same class. (Courtesy of the Brenner family.)

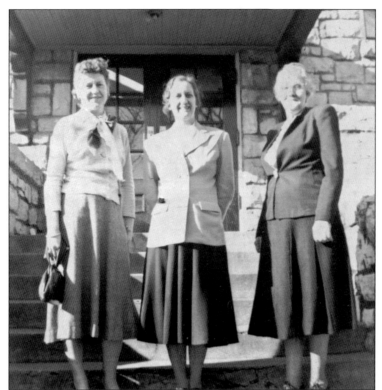

The Worthington School faculty—a teacher for each of the classrooms—pose on the school steps in 1957. They are, from left to right, Lillian Wasson, first- and second-grade teacher; Mrs. J.T. Highfield, third- and fourth-grade teacher; and Elizabeth Harrell, fifth- and sixth-grade teacher and school principal. (Courtesy of the Brenner family.)

Worthington School teacher and principal Elizabeth Harrell lived in the cottage next door to the school on the Netherton property. Netherton donated the land for the school. (Courtesy of David Simcoe.)

Elizabeth Harrell was photographed in her classroom at Worthington School. She was born in 1895 in Grayson County and, when she was 18 years old, began teaching in the one-room school where she had been a student the year before. She taught in Grayson county one-room schools prior to her 33-year career teaching in Jefferson County. Harrell taught and was principal at Worthington for 27 years and taught at Zachary Taylor Elementary School after Worthington was closed. (Courtesy of the Brenner family.)

After a long courtship, Elizabeth Harrell (1895–1990) married Edward Brenner (1897–1956) in June 1956. It was the first marriage for both. Unfortunately, Edward died a few months later. Elizabeth continued to teach until she retired in 1965 after teaching for 50 years. (Courtesy of the Brenner family.)

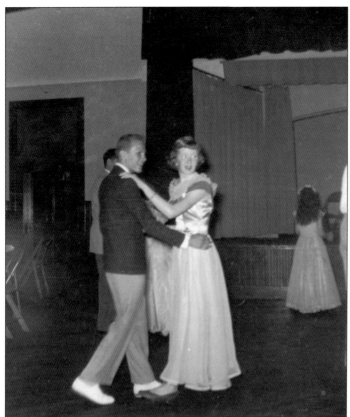

Barbara Edwards and Winston Chamberlain are pictured here at a dance in the Worthington School auditorium. The Jefferson County Recreation Department held after-school dance lessons for the students, where they were introduced to ballroom as well as tap and ballet dancing. The photograph below shows the curtain call for the Worthington School's 1955 annual operetta, *The Princess That Could Not Cry*, which included almost all of the school's 80 pupils in some capacity. It was performed on the stage in the school auditorium. (Left, courtesy of Barbara Edwards Anderson; below, courtesy of the Brenner family.)

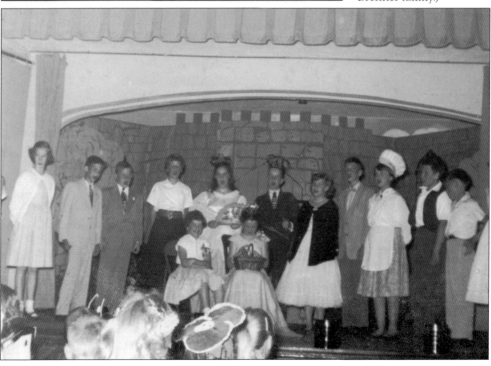

Thelma Kaelin, the crossing guard at Worthington School for many years, is shown in 1955 at her post on Brownsboro Road. There were no crosswalks and hardly any pedestrians in rural Worthington, but she watched for oncoming traffic and directed the cars coming out of the school driveway. (Courtesy of the Brenner family.)

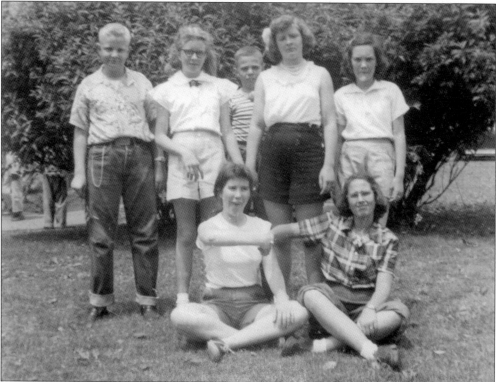

Clowning and frowning, members of the 1952 sixth-grade class pose on their last day at Worthington School. Pictured, from left to right, are (first row) Rosetta King and Judy Gottbrath; (second row) Earl Long, Barbara Edwards, David Hardin, Lula Belle Cooke, and Barbara Deacon. The eighth member of the class, Carol Brenner, took the photograph. (Courtesy of the Brenner family.)

Worthington School can be seen in the background of this softball game photograph from the 1950s. The grounds around the school had mature trees and beautiful plantings with a large open area in back for playing fields. The group of Worthington girls below in 1953 includes, from left to right, (first row) Patsy Carden, Mary Ann Schuman, Barbara Jean Hatfield, Bonnie Sue Edwards (second row) Marilyn Skaggs, Sharon Brenner, Mary Lee Hatfield, and Betty Kaelin. (Both, courtesy of the Brenner family.)

Six

CHUCHES CLOSE TO HOME

Rev. Edwin N. Rock and his wife, Elsie Greer Rock, pose at the entry of Springdale Presbyterian Church. Reverend Rock was the church's fourth minister and served there from 1925 to 1936. The Sunday school addition was added in 1928 under his direction. (Courtesy of the Brenner family.)

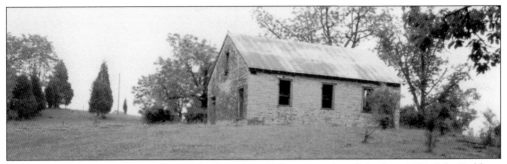

A log church predated the Wesley Methodist Chapel, this stone church built in 1824. Silas Babbitt, a minister as well as a stonemason, built the chapel when he was about 20 years old. Bruce Jean, age 18, hauled and prepared the stone. Babbitt was also proprietor of a sawmill and a gristmill beside Fishback (Hitt) Creek. The building was also used as a school for a time. The last church service was held in 1892. The building is on private property. (Courtesy of Carl Haunz Jr.)

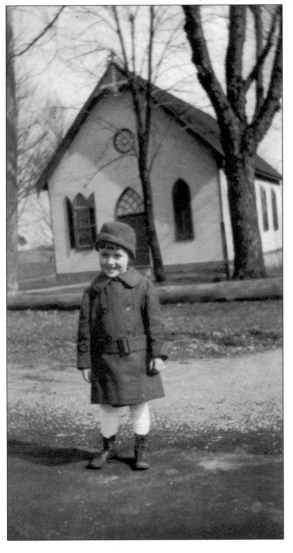

There were nine charter members of the Springdale Presbyterian Church. They were Zerelda Shake Goins and her daughters, Mary Jane and Minnie Ann Goins; Mr. and Mrs. W.W. Young; Mr. and Mrs. Hancock Taylor; William Woemer; and Dr. J. E. L. Harbold. Mrs. Young and Mrs. Taylor led the effort to establish a Presbyterian church in the neighborhood and, beginning in 1881, raised over $1,700 for the new church. The foundation was laid in 1881 and the building was dedicated on July 3, 1882. The cost was $1,766. W.W. Young supervised the construction assisted by Hancock Taylor. The Maddox family lived across Brownsboro Road from the church. Here, Kiefer Maddox poses in front of the church around 1923. (Courtesy of the H. Kiefer Maddox family)

On May 17, 1893, Theodore Barbour Chamberlain (1867–1955) and Sarah Elizabeth Wilson (1875–1966) were the first couple to marry at Springdale Church. In the photograph, they pose at the well in 1953 for their 60th anniversary. (Courtesy of Clara Chamberlain Cruikshank.)

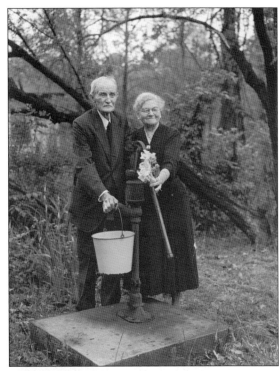

The picturesque country church was the subject of a 1952 newspaper photograph. In the foreground are the Heick family—from left to right, Carol, Eleanora, Janet, Norma (behind Janet), and Henry Heick. In the background are Barbara, Herbert, and Claudine Edwards. (Courtesy of the Heick family.)

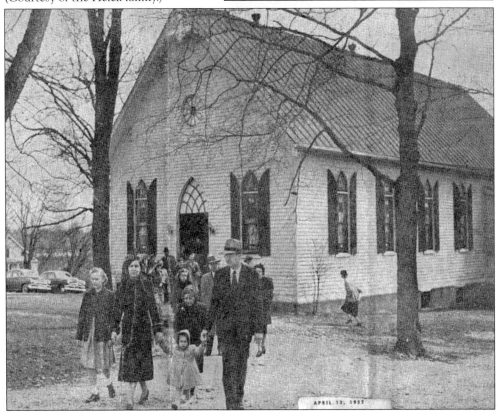

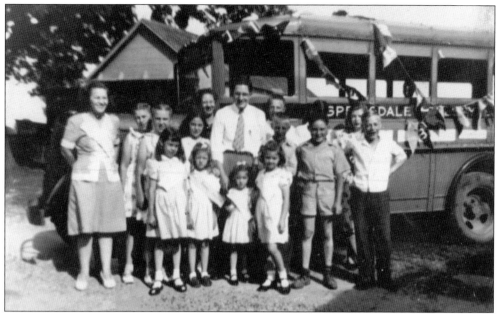

Springdale had a church bus in 1946, and it is shown here decorated for a Vacation Bible School outing. Gathered in front of the bus are, from left to right, (first row) Mary Wilder; Barbara Edwards; Sharon Brenner; Carol Brenner; Kenny Jaegers; and Glen Hochstrasser; (second row) Thelma Brenner, teacher, Beginners Department; three unknown girls; Dottie Klein; the minister, Rev. Thomas Chalmers "Chal" Henderson (1924–1974); and unidentified boys and girl. (Courtesy of the Brenner family.)

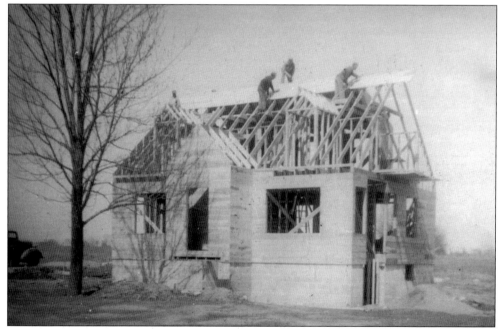

The men of Springdale church built a new manse for the minister and his wife, the Reverend Murray Pegram and Madeline Pegram. It was built on property the church owned on Barbour Lane. The 1949 photograph shows the men working on the roof. (Courtesy of the Heick family.)

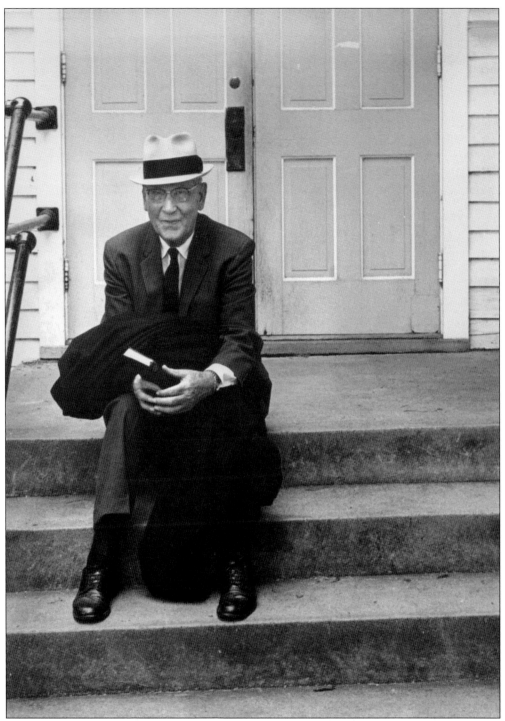

The Reverend Murray Pegram (1883–1976) is pictured on the steps of the Sunday school addition, which was dedicated in 1928. He served the church from 1947 to 1957. When this photograph was taken in 1965, he had retired, but was at the church to officiate at the wedding of Sharon Brenner and Keith Taylor in June 1965. (Photograph by Gordon Baer, courtesy of the Brenner family.)

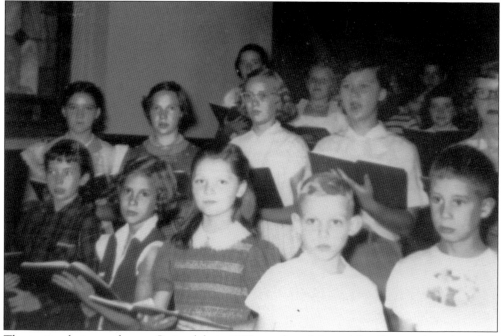

The junior choir members at Springdale in 1954 are, from left to right, (first row) unidentified, Joan Curd, unidentified, Courtney Ball, and Scott Campbell; (second row) Sharon Brenner, Barbara Carfield, Carol Heick, Carol Brenner, and Barbara Edwards; (third row) Marilyn Skaggs, Joyce Davis, and Bonnie Sue Edwards. (Courtesy of the Brenner family.)

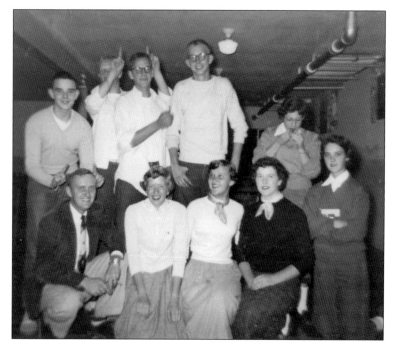

The senior-high youth group gathered in the church basement in the late 1950s. The photograph includes, from left to right, (first row), adult sponsor Jerry ?, Barbara Edwards, Carol Brenner, Linda Wallace, and Marilyn Doak; (second row) Gene Jaegers, Earl Long, Barney Long, Jack Long, and Alice Curd. (Courtesy of the Brenner family.)

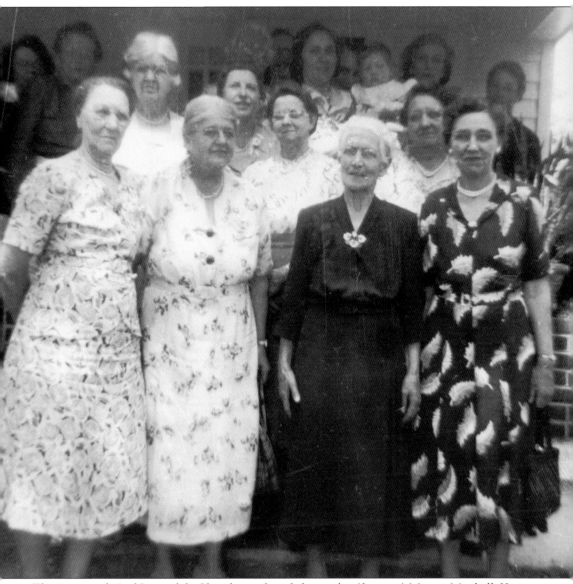

The "matriarchs" of Springdale Church are, from left to right, (first row) Mayme Mitchell, Katie Stutzenberger, Bertha Klein, and Nannie Miller; (second row) Annie Hahn, Rose Burger, Oneda Nachand, and unidentified. Most of these women were born and raised in the Worthington/Springdale area. The photograph is from 1950. (Courtesy of the Brenner family.)

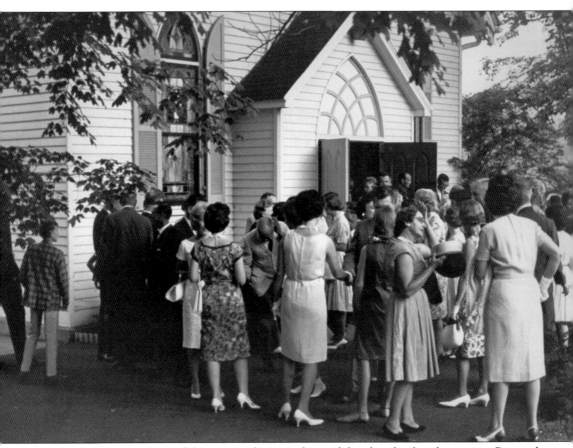

A familiar scene at Springdale was socializing in front of the church after the service. Pictured here are guests at Sharon Brenner's 1965 wedding. With the addition of the vestibule and the 1928 Sunday school addition, the church retained its original design until a new sanctuary was added in 1970. Today, the 1882 structure is surrounded by later additions to serve an active congregation. (Photograph by Gordon Baer, courtesy of the Brenner family.)

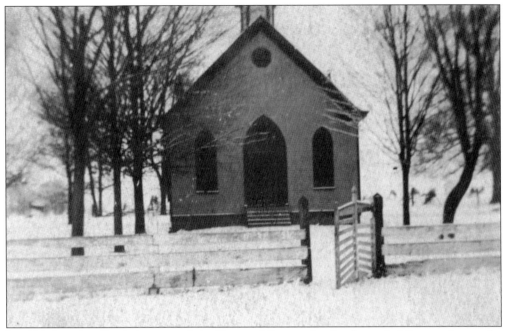

In 1880, Preacher Bartholomew and the Herr and Simcoe families began holding services at the Rock Bridge schoolhouse. They had been members of the Beargrass Christian Church and wished to establish a church closer to their homes. By 1886, the group was strong enough to finance a church building on Brownsboro Road near Worthington. The members planted trees around the new church, and fathers of the congregation named the trees for their sons. The church was dedicated November 14, 1886. Judging from the size of the trees, this photograph dates to about 1900. (Courtesy of Mildred Chamberlain Yochim.)

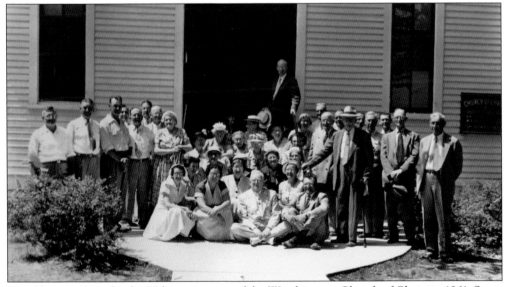

Members pose here for the 75th anniversary of the Worthington Church of Christ in 1961. Some of the members are descendants of the charter members of the church. The roster of charter families includes the Broyles, Chamberlain, Hite, Hardin, Maddox, Nuchols, Simcoe, and Zaring families. (Courtesy of David Simcoe.)

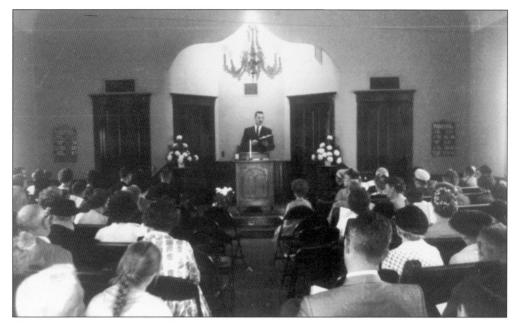

This view shows the interior of Worthington Church of Christ at the 75-year celebration in 1961. The sermon was given by J.E. Thornberry, who served as minister from 1906 to 1912. (Courtesy of Mildred Chamberlain Yochim.)

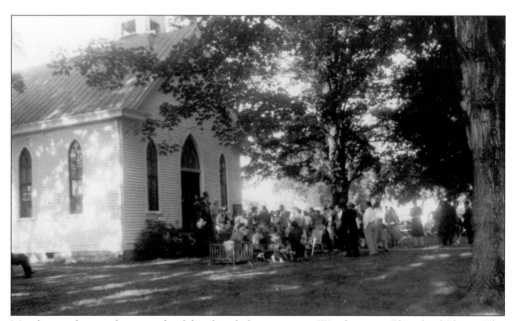

Members gather on the grounds of the church for a picnic at Worthington Church of Christ. The congregation demolished the old church building and built a new church; however, that building was sacrificed to Brownsboro Road widening and suburban development. The congregation is active in a nearby location. (Courtesy of David Simcoe.)

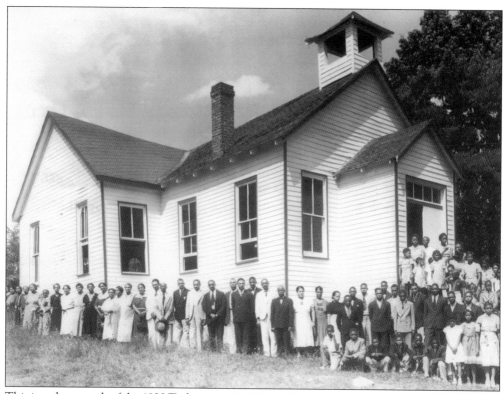

This is a photograph of the 1920 Taylortown AME Zion Church building with members celebrating probably the 100th anniversary of the church. The church dates to 1868, when a group of neighbors in Taylortown left the Goose Creek church on Westport Road to form their own church. They met at the home of Ben Taylor and named the church Taylor Chapel Church. That same year, George Nicholas Johnson donated land for a church site. There was no school for African American children in Worthington, so a school was added to the church. (Courtesy of Taylortown AME Zion Church.)

This photograph seems to have been taken at the same time as the one above. Some of the founding members' names were Taylor, Henderson, Johnson, Rudy, Homes, and Watson. The trustees when the 1920 building was built were Abner Taylor Sr., Charles Staples Sr., Nick Johnson, Tom Buchanan, Henry Trowell Sr., Norris Thornton, Rush Trowell Sr., and Clifton Thornton. (Courtesy of Taylortown AME Zion Church.)

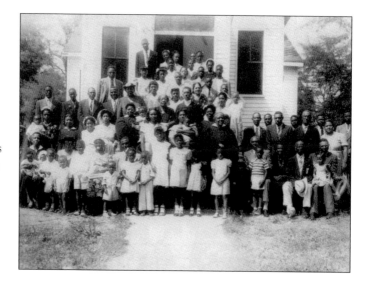

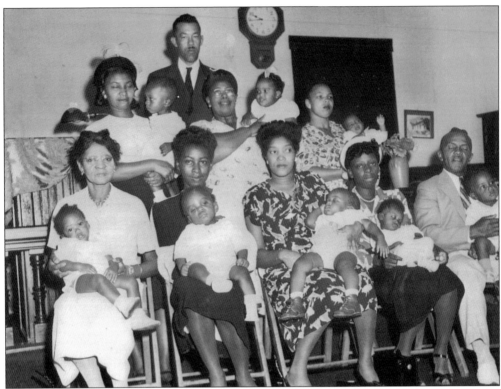

Proud parents show off their children in a baby contest, probably in the 1940s. This was one of many creative activities that the church held for fun and fundraising. The church began a building fund in 1939 and the cornerstone of the new Taylortown Church was laid on July 6, 1958. The strikingly modern Taylortown AME Zion Church, pictured below, was designed by Louisville architect William Blanton Moore (1884–1972). The building is the center of an active African American congregation. (Above, courtesy of Taylortown AME Zion Church; below, photograph by author.)

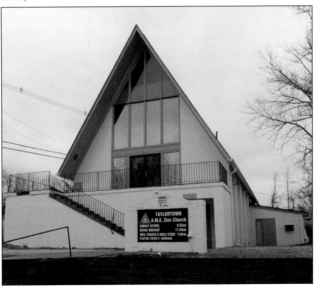

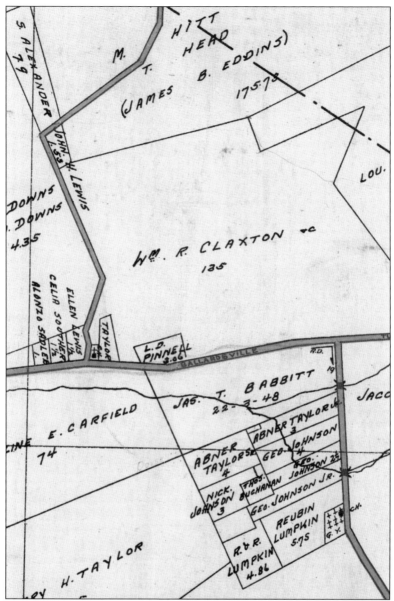

Taylortown was an African American settlement near Worthington. After the Civil War, a tract of land west of Murphy Lane was deeded to Abner Taylor, a former slave of the Taylor family. According to local history, Abner spoke with a "cultured Southern accent" and was a familiar sight, driving his horse and buggy in the Worthington community, where he was highly respected. This Louisville Title Company 1913 map shows the original Taylortown settlement. Ballardsville Road runs from west to east with Hitt Road to the north and Murphy Lane to the south. The Taylortown AME Zion Church is shown in its present location at the northeast corner of Ballardsville Road and Hitt Road. Below the Babbitt tract, which was not a part of Taylortown, are lots belonging to Abner and other members of the African American community. The Taylortown AME Zion Church, established in 1868 by the people of this community, continues to maintain an active congregation. (Section from *Atlas of Louisville and Jefferson County, Kentucky*.)

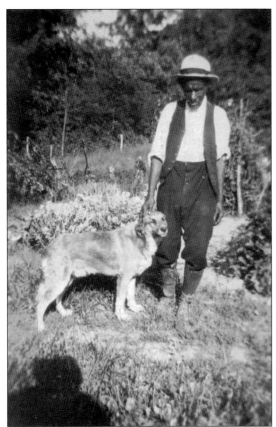

The history of the Taylortown AME Zion Church states the church was organized at a meeting at the home of Ben Taylor in 1868. He is pictured here in his garden with his dog, probably in the 1940s. Below, Alice Taylor is shown here with her husband, Ben Taylor. A newspaper obituary from 1947 titled "Former Slave Dies at 101" describes Alice as having been a slave of the Sims family. She lived in a cabin on the Sims property in Worthington. (Both, courtesy of Julia C. Young and Janet C. Ochsner.)

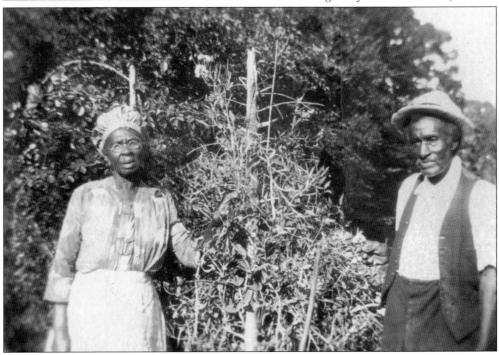

Seven

Fun, Fellowship, and Community Service

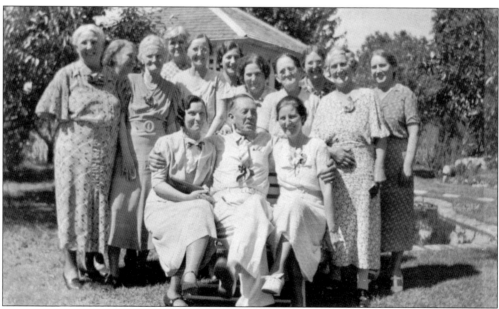

The Worthington Homemakers were photographed in 1939 at Netherton home. Pictured, from left to right, are (standing) Mrs. Brenner, Mrs. Ed Klein, Mrs. O. Johnston, Mrs. Hahn, Mrs. Maddox, Mrs. Smiser, Mrs. Heitzman, Mrs. Frederick, Mrs. Oliver Herr, Mrs. Wm. Klein, Mrs. Netherton; (seated) Mrs. Claxton, Mr. Netherton, and Mrs. Goatley. Kentucky Extension Homemakers began in 1913 as an extension program in home economics at the University of Kentucky College of Agriculture. Its purpose was to organize farmwomen for homemakers' work with Home Demonstration Clubs. In addition to socializing at club meetings, the women learned food preservation, clothing conservation, health, and sanitation. Later, the club's mission expanded to include continuing education, leadership, and volunteer community support. The Worthington Homemakers probably began in the 1920s. (Courtesy of the H. Kiefer Maddox family.)

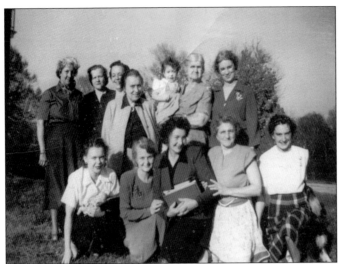

Pictured at a Worthington Homemakers 1949 meeting are, from left to right, (first row) Eloise Carden, unidentified, Clara Simcoe, Martha Ellers, and Rosella Jaegers; (second row) ? Schmiedeknecht, Nancy Ball, Mabel Brandon, ? Elrod, Annie Hahn (holding unidentified child), and Esther Stutzenberger. (Courtesy of the H. Kiefer Maddox family.)

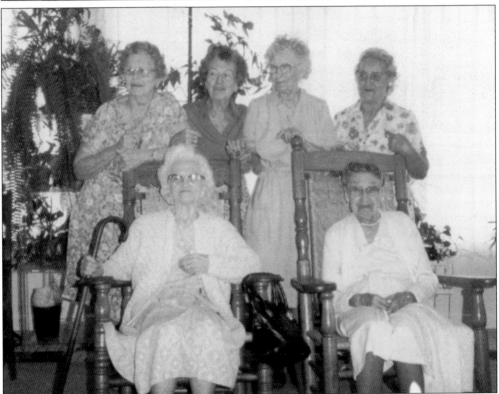

When they were younger, these women were members of the CSW Club, which seems to have been unique to the community. CSW (Community Service Workers) was founded in 1911 with eight members. The members met in each other's homes and paid monthly dues of 5¢–10¢, with special collections for wedding gifts for members and ice cream on special occasions. CSW donated to charities and had a shower for neighbors whose homes had burned. The club continued until 1948. The women pictured are, from left to right, (first row) Estelle Head and Nannie Miller; (second row) Marie Rothenburger, Clara Simcoe, Cleo Harder, and Florence Rothenburger. (Courtesy of Doris Simcoe Claiborne.)

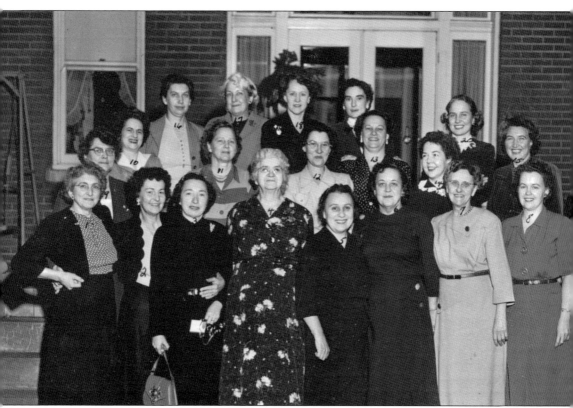

Worthington Homemakers increased their numbers in 1951. In the late 1940s and into the 1950s, families began moving from the city to build homes on lots of several acres to enjoy the benefits of country life. Some of the new women joined the women from old families in the Homemakers Club. These Homemakers are, from left to right, (first row) Martha Ellers, Clara Simcoe, Gertrude Schumann, Annie Hahn, ? Elrod, Mabel Brandon, Lou Maddox, and Eloise Carden; (second row) Eva Klein, ? Finzer, ? Craig, Dorothy Campbell, ? Eigelbach, ? Hammond, and ? Schreiber; (third row) ? Werker, ? Schmiedeknecht, Elizabeth Long, and Rosella Jaegers. (Courtesy of Gene and Kenny Jaegers.)

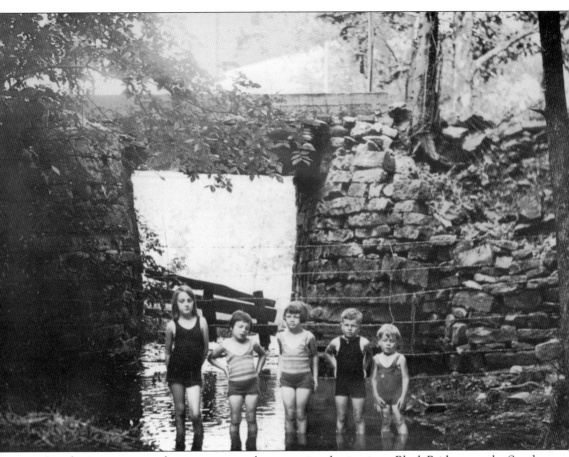

Locales in, on, or near the water are popular recreation destinations. Black Bridge over the South Fork of Harrods Creek was said to have built by slaves, but whether that accounts for the name Black Bridge is not known. It was a favorite place for children and adults to enjoy the creek and a destination for Sunday drives in the country. Here, Clara Chamberlain is with her friends in the early 1930s. (Courtesy of Clara Chamberlain Cruikshank.)

The Rock Springs Hotel was located just across the Oldham County line. It was built in 1870 by Dr. Caspari and burned six years later. There had been a large residence in that location, owned and operated by the Rader family, that served as a health resort as early as the 1860s. The main attraction at the Rock Springs Hotel was the spring, which was protected by a rock-lined enclosure. Visitors pose in front of the entrance to the spring, which was reputed to have healing powers. After the hotel burned, visitors still came to enjoy the waters. (Both, courtesy of Carl Haunz Jr.)

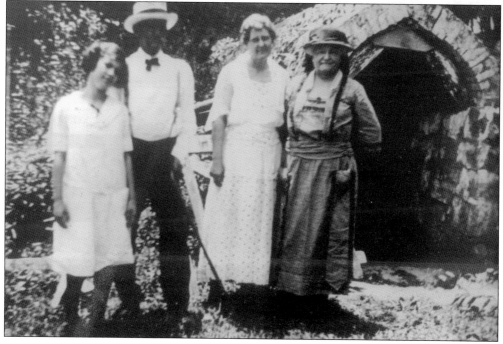

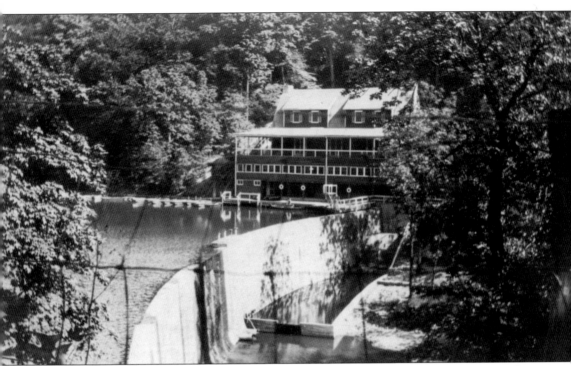

Sleepy Hollow Lake was formed by damming the South Fork of Harrods Creek. The Sleepy Hollow Club was established in the 1920s as an exclusive hunting and fishing club limited to 150 members. Thirty-one lots were sold and 23 cabins were built on the hillside overlooking the lake. The clubhouse was popular for parties and debutante balls. By 1933, membership had fallen to 24 families and the club filed for bankruptcy. It was finally sold at the courthouse door to 18 former members organized as Sleepy Hollow, Inc. The clubhouse fell into disrepair and was burned as practice for the fire department. (Courtesy of Gene Gottbrath.)

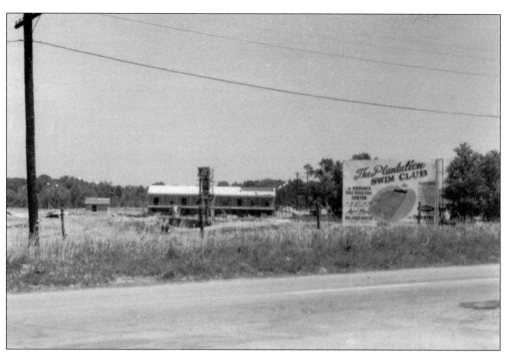

Plantation Swim Club was under construction on Westport Road in 1956. The Bollinger-Martin Construction Company built the club and the adjoining Plantation Subdivision. The club opened in 1957, providing the community with its first swimming pool. Club membership was affordable for middle-class families even though it was a private club. Ralph Wright (1921–1966) was president of the club and its head swimming coach. An energetic promoter as well as a coach, Wright created the Aquacade, a showcase for divers and water-based entertainment. Wright's swim teams were always competitive and his swimmers' awards filled the club's trophy cases. (Both, courtesy of Alice Wright Belknap.)

The diving tower at Plantation, shown here under construction in 1956, was the first of its kind in the Louisville area. The club showcased divers from all over the country at its annual Aquacades. Alice Wright was Ralph Wright's daughter and a national swimming champion in the breaststroke. In this photograph, she is working as a lifeguard at the Plantation Club pool. The clubhouse is in the background. (Both, courtesy of Alice Wright Belknap.)

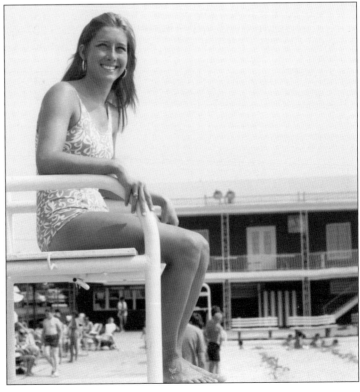

The Worthington Cemetery grounds were cared for by Carl Chamberlain for many years and later by his son-in-law, Ken Yocum. A dedicated volunteer board oversaw the cemetery business and collected donations for its upkeep. The board has turned over the cemetery maintenance to Northeast Christian Church. This 1917 receipt is for a 200-square-foot lot in Worthington cemetery. Chris H. Brenner paid $30 for the lot where he and his wife are now interred. (Both, courtesy of the Brenner family.)

Worthington Cemetery Company.

No. _____

Worthington, Ky. _____ August 30 1917

✦ Received of _Chris. Brenner_

Thirty _____ X Dollars,

which entitles _him_ to this certificate of Ownership for _one half_ Lot in the

WORTHINGTON CEMETERY,

No. _12_, Section _D_, containing about _200_ square feet,

Subject to all by-laws, rules and regulations, made and to be made by the Board of Directors of the Company, and subject to the following understanding and agreement:

1. Owners may by last Will and Testament, or by writing directed to the Company, signed by the owner and attested by two witnesses, determine who shall control the right of burial in their lots after their death.
2. In default of such written direction, the lineal descendents of the deceased owner and the husbands and wives of said descendants in the order of their death and application made therefor, shall have the right; and
3. There being no lineal descendents, the heirs at law in like order and application therefor, shall have the right of burial.
4. But any of the lineal descendents may release the right of burial for himself and all persons descended from him and their husbands and wives by writing filed in the office of this Company and attested by the President or Secretary thereof.

But no sale of any interest in this lot shall be made without the previous consent of the Board of Directors.

Thomas Hite
PRESIDENT.

G. W. Nuckols
SECRETARY.

H. H. Sims
TREASURER.

$ 30.00

Many of the community's first families are buried in the cemetery, which dates to 1873. The Skinner family monument and grave markers are shown here. When the cemetery was new, there was an arched iron gate at the entry and a row of evergreens fronted the property on Brownsboro Road. The gate disappeared many years ago, but the trees survived until the road was widened and utility lines installed. (Photograph by the author.)

BIBLIOGRAPHY

Beers & Lanagan. *Atlas of Jefferson and Oldham Counties, Kentucky.* Philadelphia: 1879.

Bergmann, G.T. *Map of Jefferson County, Kentucky.* Louisville: 1858.

Bullitt, Neville S. "Old Homes and Landmarks." Unpublished notes, Filson Historical Society.

Chamberlain, Russell Edward. "The Early Harrods Creek Settlements and the Kentucky Branch of the Chamberlain Family." Unpublished manuscript, 1994.

Jones, Elizabeth F. *Jefferson County Survey of Historic Sites in Kentucky.* Louisville: Jefferson County Office of Historic Preservation, 1981.

Kentucky Digital Library. *Voice Jeffersonian.*

Keys, Leslee F. and Donna M. Neary. *Historic Jefferson County.* Louisville: Jefferson County Historic Preservation and Archives, 1992.

Kleber, John E. *Encyclopedia of Louisville.* Lexington: University Press of Kentucky, 2001.

Louisville Title Company. *Atlas of Louisville and Jefferson County, Kentucky.* Louisville: Louisville Title Co., 1913.

Maddox, Kiefer, Elsie Maddox, George Freibert, and John S. Egan in unpublished oral history interview, November 25, 1994.

Oldham County Historical Society, *History & Families Oldham County, Kentucky: The First Century, 1824–1924.* La Grange, KY: Oldham County Historical Society, 1996.

Renau, Lynn S. *So Close from Home.* Louisville: Herr House Press, 2007.

Schulman, Sol. "Best Land Worst Farmers Found at Worthington." *Courier-Journal,* April 20, 1941.

Sinclair, Ward, and Harold Browning. "King Potato Ruled O'Bannon, Worthington at Peak of Their Heyday." *Louisville Times,* November 12, 1965.

Williams, L.A. & Co. *History of the Ohio Falls Cities and their Counties.* Cleveland, OH: 1882.

Discover Thousands of Local History Books Featuring Millions of Vintage Images

Arcadia Publishing, the leading local history publisher in the United States, is committed to making history accessible and meaningful through publishing books that celebrate and preserve the heritage of America's people and places.

Find more books like this at
www.arcadiapublishing.com

Search for your hometown history, your old stomping grounds, and even your favorite sports team.

Consistent with our mission to preserve history on a local level, this book was printed in South Carolina on American-made paper and manufactured entirely in the United States. Products carrying the accredited Forest Stewardship Council (FSC) label are printed on 100 percent FSC-certified paper.

MADE IN THE USA